Artful Animals

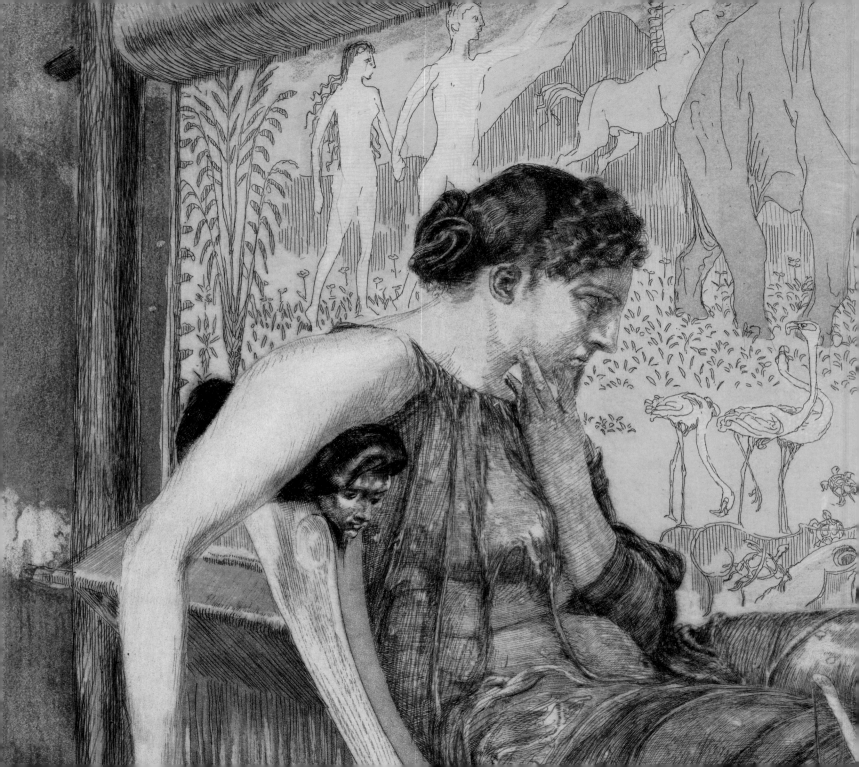

Artful Animals

COLLEEN TERRY

FINE ARTS MUSEUMS OF SAN FRANCISCO

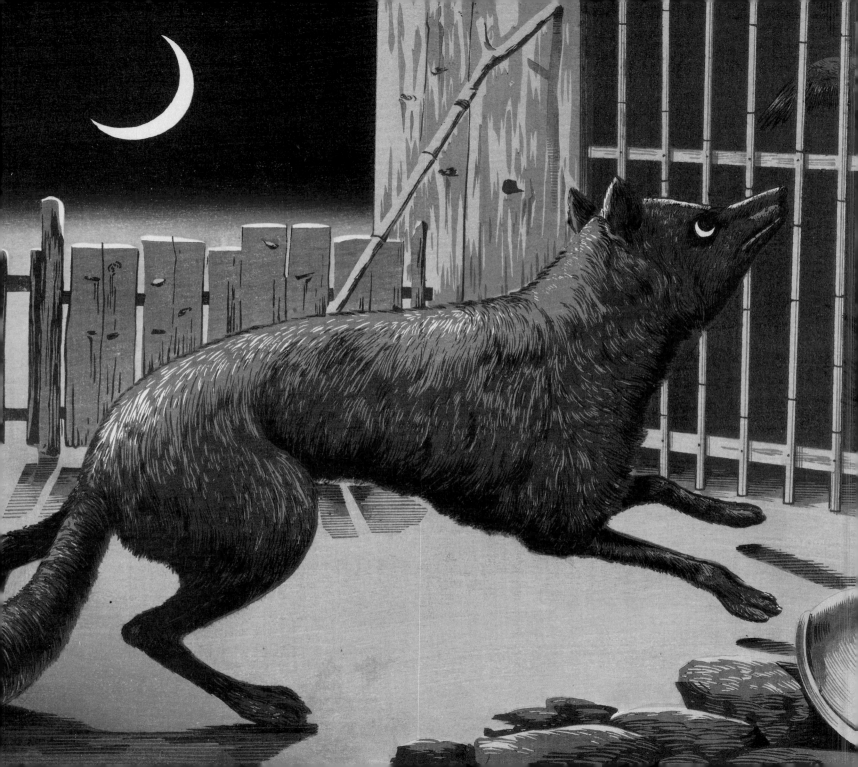

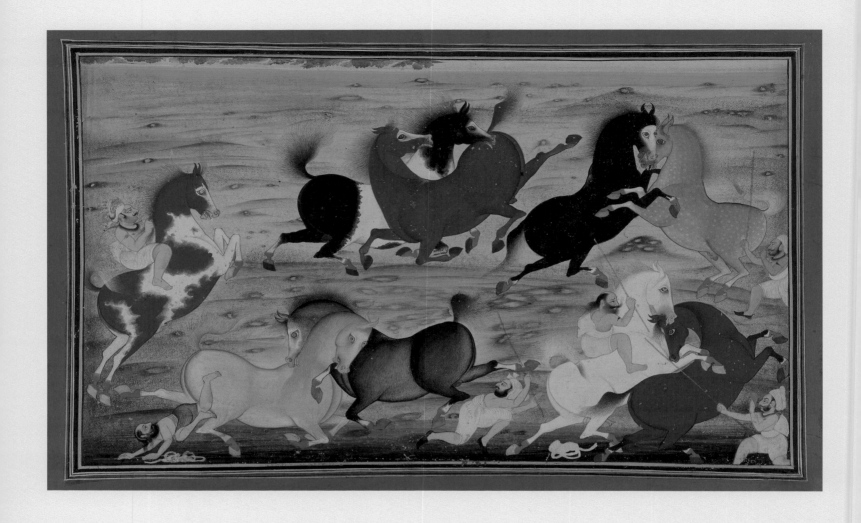

Attributed to Chokha (Indian, Rajasthan, Devgarh, active early 19th century), *Bounding Horses*, ca. 1800. Opaque watercolor, 27.6 × 40.6 cm (10⅞ × 16 in.). Katherine Ball Collection, 41.43.6

Foreword

The de Young and the Legion of Honor—the two museums that together form the Fine Arts Museums of San Francisco—are full of great artworks that cover a wide variety of subject matter. With all these treasures at hand, I am surprised by how often visitors are drawn in particular to works that depict animals.

As someone who has long appreciated the companionship of dogs, I recognize an artist's motivation to capture the charm and mystery of the animal kingdom. *Artful Animals* provides a remarkable look at the creativity and depth of feeling that artists have brought to bear on depictions of animals of all types, such as a lithograph of a bull by Picasso, and an anonymous seventeenth-century watercolor of two royal antelopes.

This selection of graphic arts draws from the Museums' renowned Achenbach Foundation for Graphic Arts, the largest collection of works on paper in the western United States. It is a rare privilege to be able to share them with you, as our works on paper are among the most vulnerable in the Museums' collections and can be on view for only short periods of time.

Artful Animals, produced with the generous support of the Achenbach Graphic Arts Council, hints at the Achenbach's vastness and diversity. The richness of these holdings has allowed us to present many other recent exhibitions and publications such as *Impressionist Paris: City of Light*, *Artistic San Francisco*, and *Rembrandt's Century*.

I hope you enjoy the delightful menagerie that populates these pages.

Diane B. Wilsey
President, Board of Trustees
Fine Arts Museums of San Francisco

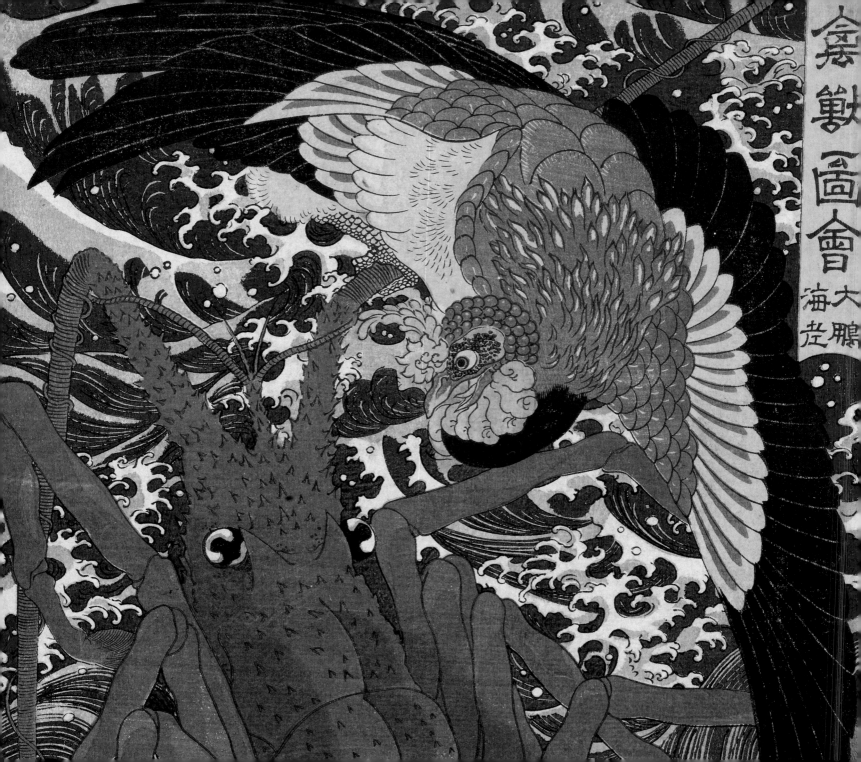

禽獣圖會　大鵬　海老

Artful Animals

COLLEEN TERRY

For millennia, the animals that share our world have found their way into visual expressions as greatly varied as the roles they play in our lives. Domesticated animals have been revered as pets and companions, have been used as sources of food or labor, and have become subjects of spectacle, religious sacrifice, and even sporting events. When encountered in the wild, untamed animals may exhibit behaviors that strike terror into our hearts; they may also inspire wonder and awe. Given that animals and humans have coexisted in this evolving balance from time immemorial, it is not surprising that our artistic creations contain diverse references to these other creatures in our realm.

Although depictions of animals date from prehistoric times, the advent of printing in the West in the early fifteenth century greatly enhanced our knowledge and awareness of the animal kingdom. Where stories and myths of curious beasts in faraway places once ignited the imagination, printed images

marked by acute observation and attention to naturalistic detail paved the way for scientific inquiry into the natural world that continues to this day.

Certain artists from this era onward were deeply concerned with rendering animals with a great degree of accuracy. Northern Renaissance masters such as Albrecht Dürer and Lucas Cranach the Elder often studied real-life models, whether cadavers or living specimens found in the zoological gardens and private menageries that proliferated in flourishing cities like Brussels. When circumstances permitted, they would even travel great distances for the opportunity to observe creatures about which they had only heard tales, as Dürer once set out to do when he heard news of a beached whale on the Netherlands' Zeeland coast. (Unfortunately, he arrived too late, the tide having carried the whale back out to sea.) When firsthand study was impossible, artists relied on textual descriptions as the basis for their images, as

Dürer did in order to create his famed rhinoceros woodcut of 1515. They also worked from renderings by artists who had come before; having never seen a lion dead or alive, Cranach used as models his predecessors' prints and drawings, which inspired the crouching creature that inhabits the lower realm of his animal-filled Eden (fig. 1).

Religious subjects such as Adam and Eve in paradise and Noah's Ark (see page 21) offered artists an opportunity to incorporate exotic creatures such as lions into familiar settings. But these depictions followed well-established traditions that ensured that the meanings of the compositions were not lost. In representing Adam, Eve, and the introduction of original sin, Cranach could reasonably expect his audience to understand his symbolic use of animals. In this print he included specific species to remind viewers of Christ and the redemption he would later bring to mankind. The stag, which appears multiple times throughout the composition, is a common symbol of Christ, as are the grazing sheep, which make reference to his sacrifice on the Cross. Yet another symbol of Christ is the horse, seen underneath Eve's upraised arm. Startled, it appears ready to flee the scene, presaging the monumental changes to Eden that are about to result from the serpent's deceitful whispers into Eve's ear.

Other religious subjects were equally alluring for artists interested in depicting animals. Creatures would naturally surround

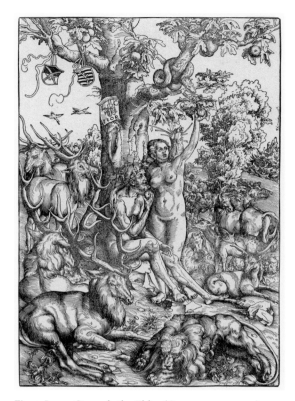

Fig. 1. Lucas Cranach the Elder (German, 1472–1553), *Adam and Eve in Paradise*, 1509. Woodcut, 33.8 × 23.2 cm (13⁵⁄₁₆ × 9⅛ in.). Museum purchase, gift of Col. David McC. McKell, 1960.71.4

any image of Saint Eustace, patron saint of hunters, but in Dürer's rendering of the moment of his conversion to Christianity, the primary subject—the pagan Eustace—practically disappears among the beasts around him (fig. 2). Dürer populated his landscape with artfully arranged animals, primarily in profile, and Eustace's vision between the stag's antlers of Christ on the

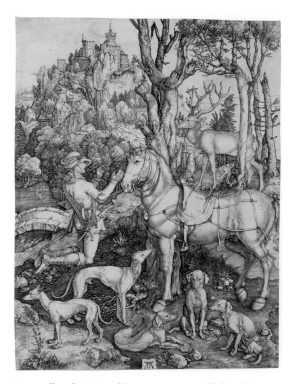

Fig. 2. Albrecht Dürer (German, 1471–1528), *Saint Eustace*, ca. 1501. Engraving, 35.1 × 25.3 cm (13¹³⁄₁₆ × 9¹⁵⁄₁₆ in.), cropped within plate mark. Gift of Julius Landauer, 1961.53.15

Cross blends into the bountiful branches of the nearby hillside copse. Because the stag has dual significance—at once the hunter's prey and a symbol of Christ—it connotes Eustace's religious quest as well.

The attention paid to the figure of the horse from which Eustace has dismounted suggests that the nominal subject of Dürer's print may in fact have been of secondary import. Dürer idealized the animal's pro-

portions, using geometry as the basis for the relationships of its body parts. He shows this creation to advantage, in profile. Just a few years later, in 1505, Dürer used the horse from *Saint Eustace* as the model for an equine engraving known as *The Small Horse*, having further refined a system of proportions that had preoccupied him in the intervening years.

It was the *Saint Eustace* dogs, however, that proved to have the longest-lasting impact within the history of art. The variety of poses that Dürer incorporated into this group of hunting dogs was remarkable for the time. The eminent writer and historian Giorgio Vasari was laudatory in his discussion of this aspect of the print, and other artists must have agreed with his appraisal, for quotations of these dogs appear in paintings by Parmigianino and Correggio, Italian artists of Dürer's time, as well as in works by the nineteenth-century English artist Edward Burne-Jones. Though the dogs in Dürer's composition were not necessarily intended to stand for anything other than what they are—partners in the hunt—they may also symbolize fidelity.

Like any other animal, a dog may assume alternate symbolic meanings depending on the context in which it is presented and the questions that a viewer thinks to ask. Take, for example, Hendrick Goltzius's charming portrait of his apprentice Frederick de Vries (fig. 3). The child is poised, ready to clamber onto a large hunting dog as if it were a small pony. The two are clearly known to one

another, as the dog makes no effort to escape the child's grasp. Evidence suggests that the dog was modeled after Goltzius's own; the same creature figures in a number of the artist's sketches.

More than a beloved pet's portrait, however, the dog also signifies Goltzius himself, Frederick's teacher and guardian, who was charged with caring for the boy's moral and artistic upbringing. At the end of his renowned *Schilder-boeck (Book of Painters)*, published in 1604, noted historian Karel van Mander describes the allegorical meanings associated with certain animals. He correlates the dog with an "upright teacher, who must bark fearlessly and constantly, and keep watch over the souls of men and punish their sins." It seems certain that this was the meaning that Goltzius intended with his engraving, which, in the cartouche at the dog's feet, is dedicated to his friend Dirk de Vries, Frederick's father, who was living far away in Venice. The portrait would have offered reassurance to an anxious parent that his son was doing well under Goltzius's watchful eye. The print's significance is further illuminated by the Latin verse in its lower margin, which translates as: "Simplicity seeks and loves faithfulness/ The faithful dog and the innocent boy." From this inscription we might guess that the dove that Frederick holds aloft represents his own simplicity and innocence, connotations also described in Van Mander's book.

Books like Van Mander's that ascribe specific symbolism to various members of

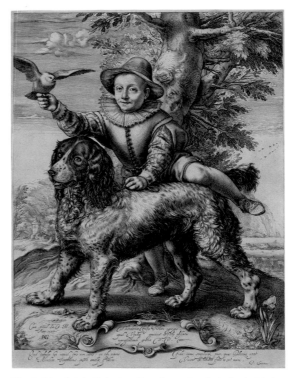

Fig. 3. Hendrick Goltzius (Dutch, 1558–1617), *Frederick de Vries with His Dog*, 1597. Engraving, 36.1 × 26.7 cm (14³⁄₁₆ × 10½ in.). Museum purchase, Achenbach Foundation for Graphic Arts Endowment Fund, 2002.98.1

the animal kingdom were helpful to seventeenth-century artists and audiences alike, but the metaphors Van Mander details were not generally of his own creation. Dating back to far earlier times, the symbolism of different species was often established through interpretations of behaviors observed in the wild. Texts such as *Aesop's Fables* (sixth century BC) and Pliny the Elder's *Natural History* (first century AD) offer accounts of

animals that permeate our associations with these creatures even today.

Pliny's *Natural History*, one of the largest and most comprehensive surviving texts from ancient Rome, provides observations and explanations of the various animals known at the time. With its breadth of content, citations of original sources, and sophisticated indexing of subjects, this work served as the model for all encyclopedias that followed. Books eight through ten are devoted to creatures of the land, sky, and sea, and book eleven investigates the insect world. Though partially zoological, each entry is largely given over to anecdote, particularly concerning how the animal subjects relate to human life and history (see page 23).

Unlike Pliny's text, the fables of Aesop were not based on zoological observations; they offer an alternative way to think and learn about animals while also instructing on human nature. A series of stories largely meant to teach moral lessons, they feature creatures who act and speak like people while also retaining their individual animal traits. Intended for a broad audience, these stories appealed in part by suggesting that humans may have quite a bit to learn from the world's fauna.

Aesop himself is a historically elusive figure whom many believe to have been a slave freed for his wit. In a volume of his fables illustrated by noted seventeenth-century animal painter Francis Barlow, the frontispiece (fig. 4) features a portrait of Aesop in what might be regarded as a reversal of the legend

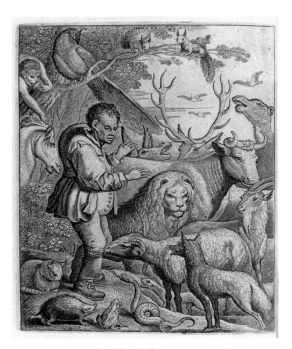

Fig. 4. Francis Barlow (English, ca. 1626–1702), frontispiece in the book *Les fables d'Ésope, et de plusieurs autres excellens mythologistes* (*Aesop's Fables and Many Other Excellent Myths*) (Amsterdam: Étienne Roger, 1714), 1666. Engraving, 19.6 × 15.9 cm (7¹¹⁄₁₆ × 6¼ in.). Achenbach Foundation for Graphic Arts, 1963.30.38638.1

of Orpheus, who could charm animals with his music: here the animals seem to transfix the hunchbacked storyteller, revealing the wisdom that Aesop will impart to humankind through his clever stories.

Animals from all parts of the world converge on this page, preparing readers for the diverse menagerie that populates Aesop's tales. A similar compositional scheme is seen in the Mughal dynasty Indian miniaturist Miskin's minutely detailed *Animal Scene* (fig. 5).

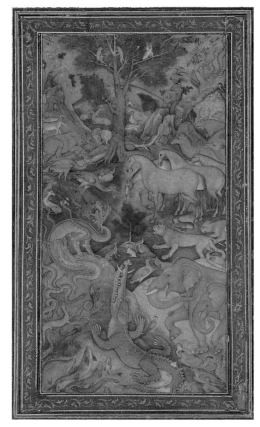

Fig. 5. Miskin (Indian, Mughal, active ca. 1580–1604), *Animal Scene*, ca. 1600. Transparent and opaque watercolors, black ink, and gold, 23 × 11.3 cm (9¹⁄₁₆ × 4⁷⁄₁₆ in.). Gift of Arthur Sachs, 1951.17

While the artists of both works represented their creatures realistically in terms of anatomy, neither seems to have seriously considered the ways their animal actors would respond to sharing such close quarters in the natural world. Such felicity appears across a variety of visual traditions (see fig. 1, for example) and may suggest a universal human desire for the peace and harmony among living things that fills so many of our creation stories, if not our history.

Ancient narratives have not only contributed to our understanding of morality, but have also played a role in how we relate to our physical world, such as the way we see the night sky. Leo is recognized by much of the world as a constellation taking the form of a lion, king of the beasts. The representation originates from the lion of ancient Greek mythology that was killed and skinned by Heracles in one of his twelve labors. A vicious monster whose pelt was impervious to arrows and knives and who therefore could not be killed by the usual methods, the lion once terrorized the town of Nemea. In one telling of the legend, Heracles's arrows left the creature unscathed until the mighty warrior shot one into its open mouth. Another version of the story claims Heracles defeated the animal with his unmatched strength, strangling the lion after finding it asleep in a cave. To prove that he had completed his task, Heracles was charged with skinning the lion; as the knife that he took to its hide had no effect, he used the lion's own claw to successfully remove the pelt. To commemorate Heracles's bravery and heroism, Zeus created a picture of the defeated lion out of the stars.

Dürer is credited with designing in 1515 the first printed star charts featuring the constellations of the northern and southern celestial hemispheres. Thanks largely to his expert precision and graphic rendering, Dürer's woodcuts quickly became models for

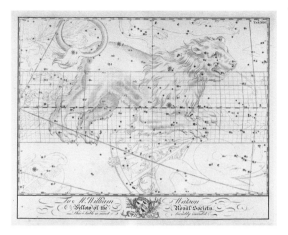

Fig. 6. Unknown artist (possibly Dutch, active mid-17th century), after Alexander Mair (German, ca. 1559–after 1616), *Leo*, from the set of prints *Uranographia Britannica* by John Bevis, ca. 1749–1750. Engraving, 31.8 × 38.4 cm (12½ × 15⅛ in.). Achenbach Foundation for Graphic Arts, 1963.30.13967

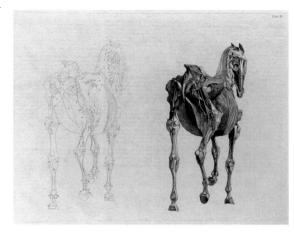

Fig. 7. George Stubbs (English, 1724–1806), *The fifteenth Anatomical Table, of the Muscles, Fascias, Ligaments, Nerves, Arteries, Veins, Glands, and Cartilages of a Horse, viewed posteriorly*, in the book *The Anatomy of the Horse* (London: J. Purser, 1766). Etching with engraving, 37.5 × 47.8 cm (14¾ × 18¹³⁄₁₆ in.). Achenbach Foundation for Graphic Arts, 1963.30.2714.24

generations of artists and astronomers. In the middle of the eighteenth century, John Bevis was one of a number of astronomers intent on updating the map of the stars. Using his own discoveries as well as other recent findings, Bevis set out to produce a new set of charts that came to be known as the *Uranographia Britannica*. The Bevis celestial maps updated Johann Bayer's *Uranometria* (Augsburg, 1603) and improved upon its predecessor's artistic quality, but the iconography remained largely unchanged from Dürer's sixteenth-century study, showing in this example (fig. 6) a majestic lion, Leo, reigning over the skies.

Such renderings of natural phenomena signaled the increasing importance of observation among the educated elite, and by the eighteenth century Enlightenment ideals were well entrenched in many artistic communities. Scientific rationalism and thirst for knowledge were driving forces linking art and science in the minds of notables such as George Stubbs, an English painter known for his pictures of animals, horses in particular (see fig. 7 and page 42). The intense realism of his depictions—many of them dazzling portrayals of individual creatures and personalities—was partly a consequence of the artist's interest in anatomy. To immerse himself in his specialty, Stubbs retreated to the country to study the horse's physicality firsthand. He spent months dissecting equine specimens, making detailed annotated

drawings as each layer of the body was stripped away. These drawings would become the basis for *The Anatomy of the Horse*, a book that includes plates engraved and etched by Stubbs himself. Published in 1766, Stubbs's book became a standard source not only for artists but also for veterinary studies well into the nineteenth century. Through scientific observation and illustration artists such as Stubbs and the great American naturalist James John Audubon (page 35)—who also worked within the realm of science, carefully documenting the appearances and habitats of North American birds and quadrupeds—have helped to codify our body of knowledge about a wide range of creatures.

While interest in animal symbolism lost traction in some of the more scientifically inclined eighteenth-century circles, it persisted in others, evolving to accommodate the times. Artists including William Hogarth in England (see page 47), and later the illustrator known as Grandville in France (see page 63), used animals to imply various foibles in human nature, often identifying particular individuals for the brunt of their satire. Providing artistic commentary on the political and social events of the day, such works feature animals engaged in human activities for both humorous and critical effect, suggesting a multitude of meanings to a variety of audiences. The strongest of these images exploit unmistakable physiognomic references to their human subjects and popular perceptions of the animal's limitations. For example, the Spanish artist Francisco de Goya (see page 27)

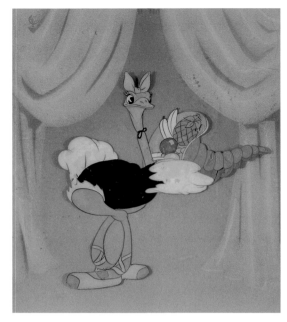

Fig. 8. Walt Disney Studios (American, active 20th–21st centuries), *Fantasia: Mlle. Upanova and Fruit*, 1940. Opaque watercolor on celluloid, 21.5 × 18.8 cm (8⁷⁄₁₆ × 7³⁄₈ in.), image. Gift of Dr. William McPherson Fitzhugh Jr., 1962.57.43. © Disney

directed his famously satirical wit toward the aristocracy, saying of the donkey: "This poor animal has been driven mad by genealogists and heralds. He is not the only one." The donkey, or "ass"—slang popularized by William Shakespeare to connote stupidity—substitutes for what Goya saw as the inbred and dim-witted aristocracy of his day.

Unlike the eighteenth- and nineteenth-century satirists who imparted such biting commentary, the Walt Disney Studios in the twentieth century had a different goal when presenting animals with distinctive human

characteristics. The anthropomorphic pink ostrich Mlle. Upanova (fig. 8) in Disney's 1940 animated classic *Fantasia* offers a comical view of a pampered ballet mistress who instructs her gawky flock in the fine art of dance. Rather than being specifically satirical, Disney's image is presented in the spirit of pure entertainment.

In their simplification to the minimum outlines and shapes that will still render an animal such as an ostrich recognizable, Walt Disney Studios animators were not far removed from many of the currents running through contemporary art. After the invention of photography in 1839, countless artists no longer felt compelled to depict the world—and by extension the animals populating it—in naturalistic terms. Where for hundreds of years representations of cats or dogs might look more or less the same even across cultures (or at least recognizable, if rendered in the distinct style of the day), audiences were suddenly confronted with a wide range of images that turned nature on its head. By Pablo Picasso's hand, the bull—archetype of strength and a symbol of the artist's native Spain—was rendered in abstract terms with an emotional sympathy befitting its status as Picasso's personal emblem (page 26). In *Les Eyzies* by Elaine de Kooning, such reduction of form assumed a simplified linearity and an air of primordial familiarity, harking back to the numerous Paleolithic paintings found in the caves of Lascaux that so captivated the artist (page 24).

Like any other subject that appealed to twentieth-century artists, animals became rendered in a multitude of stylized ways that ran the spectrum from abstract to realist. Such currents continue in the twenty-first century. Some contemporary artists even put photography to work for them, using technology as a way to achieve stunning verisimilitude. American artist Richard McLean paints from photographs, which help him to capture even the smallest detail, down to a horse's reflections in a trailer's hubcaps (page 44), while the American photographer Susan Middleton has used technology to bring new life to a species that has been extinct for nearly one hundred years (page 59). In their adoption of realistic representation, artists such as these continue a well-established tradition while creating images that reflect a contemporary spirit. By capturing not only the appearances but the essences of the creatures that share our planet, today's artists—like Cranach and Dürer more than five hundred years ago—reflect a fascination with the animal world that has never waned.

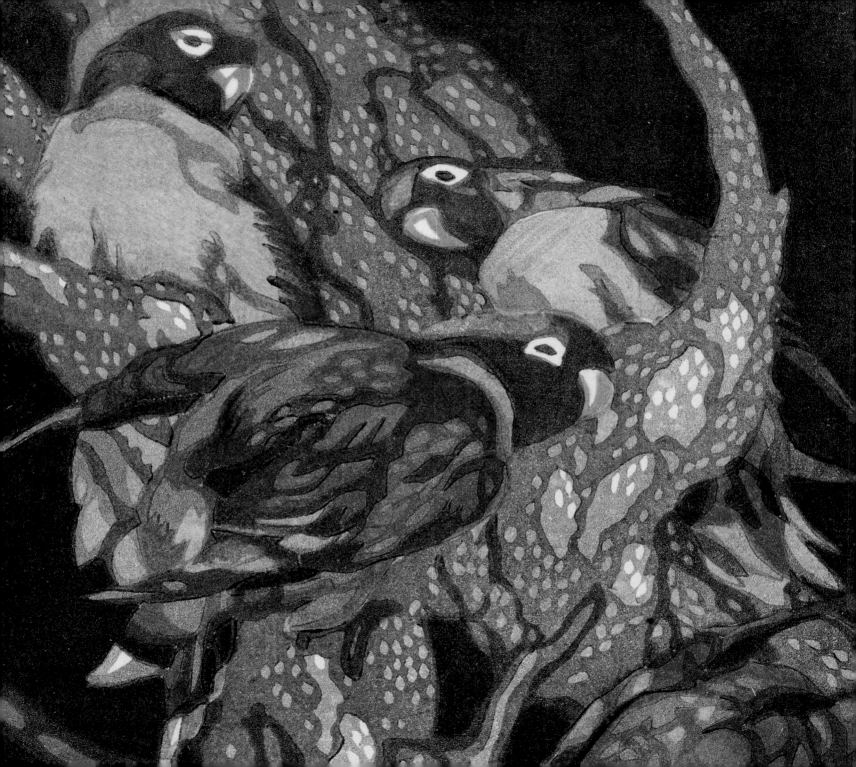

Plates

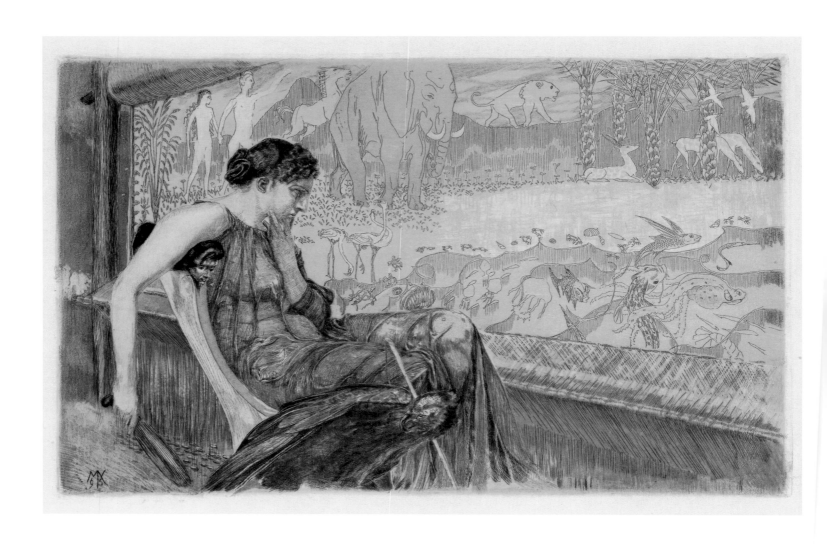

Max Klinger (German, 1857–1920), *Penelope*, 1896. Color etching and aquatint, 18.9 × 30 cm (7⁷/₁₆ × 11¹³/₁₆ in.). Achenbach Foundation for Graphic Arts, 1963.30.1556

Odysseus's faithful wife, Penelope, sits at her loom, weaving a shroud for her father-in-law. According to Homer's *Odyssey*, Penelope evaded remarriage while awaiting her long-absent husband's return, promising to consider new suitors only after finishing her project. By day she would weave, and by night she would secretly take her stitches apart, starting afresh the next morning. In Klinger's interpretation of this famous tale, Penelope's work is woven with depictions of the earth's animals.

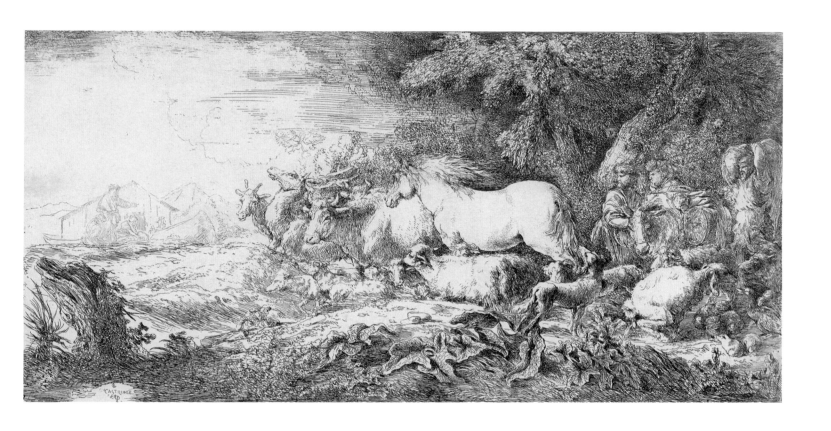

Giovanni Benedetto Castiglione (Italian, 1609–1664), *The Entry into Noah's Ark*, ca. 1650–1655. Etching, 20.6 × 40.3 cm (8⅛ × 15⅞ in.). Achenbach Foundation for Graphic Arts, 1963.30.1490

In Genesis 6–9 God calls upon the patriarch Noah to save himself and his family, along with pairs of every beast and bird of the earth, on an ark built to withstand a great flood. Castiglione's etching suggests the flurry of activity that may have accompanied the monumental undertaking of bringing all the world's creatures together.

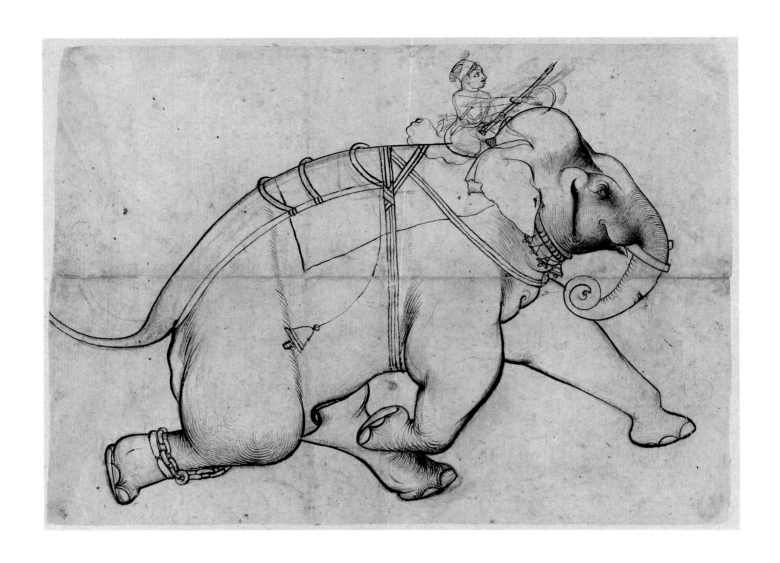

Attributed to **Sheikh Taju** (Indian, active 18th
century), *Running Elephant*, ca. 1735. Brush and
black ink over charcoal on thin "Oriental" paper,
28.9 × 39.6 cm (11⅜ × 15⁹⁄₁₆ in.), irregular. Museum
purchase, funds from the Achenbach Graphic Arts
Council, 1997.35

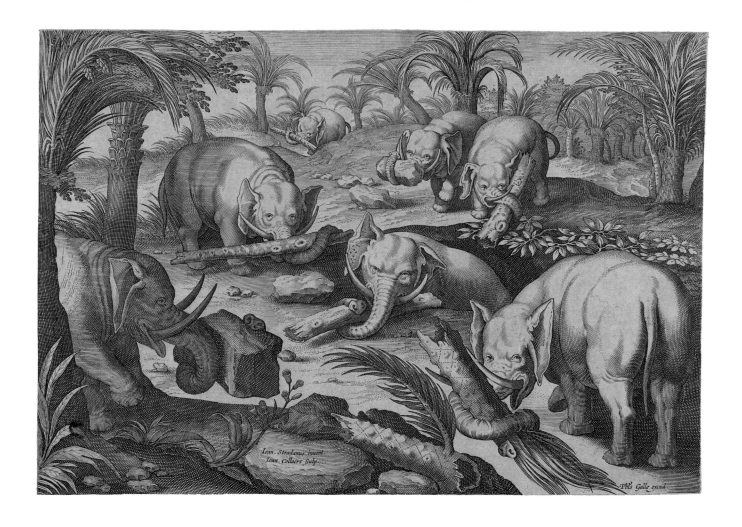

Ioan. Stradanus invent.
Ioan. Collaert sculp.

Phi's Galle excud

Hans Collaert the Younger (Flemish, 1566–1628), after **Jan van der Straet** (known as **Stradanus**) (Flemish, active in Italy, 1523–1605), *Elephants Helping Each Other from a Trap*, no. 8 from the series *Hunts and Animal Scenes*, after 1596. Engraving, 18.6 × 25.7 cm (7⁵⁄₁₆ × 10⅛ in.), cropped within plate mark. Achenbach Foundation for Graphic Arts, 1963.30.12515

Stradanus illustrated an episode in Pliny the Elder's groundbreaking encyclopedia *Natural History* that describes how elephants were captured and tamed in the first century AD. After one pachyderm fell into a hole or ditch specially dug for the purpose, the herd would endeavor to free it by piling boulders, tree limbs, and other materials into a ladder or ramp for the elephant's escape—thereby developing skills advantageous to the hunters who subsequently engaged them in physical labors.

Elaine de Kooning (American, 1920–1989),
Les Eyzies, 1985. Color sugar-lift aquatint and spit-bite aquatint, 60.7 × 91.2 cm (23⅞ × 35⅞ in.). Printed by Peter Pettengill; published by Crown Point Press, Oakland. Crown Point Press Archive, gift of Crown Point Press, 1992.167.458

This print was inspired by the Paleolithic cave paintings that the artist saw near Les Eyzies-de-Tayac, a small town in the Dordogne region of southern France. The caves are believed to have been in use from 30,000 to 10,000 BC as a site for rituals surrounding the worship of the hunt; many feature exquisite renderings of animals, primarily bulls, stags, mammoths, and a species of bison that has been extinct for millennia.

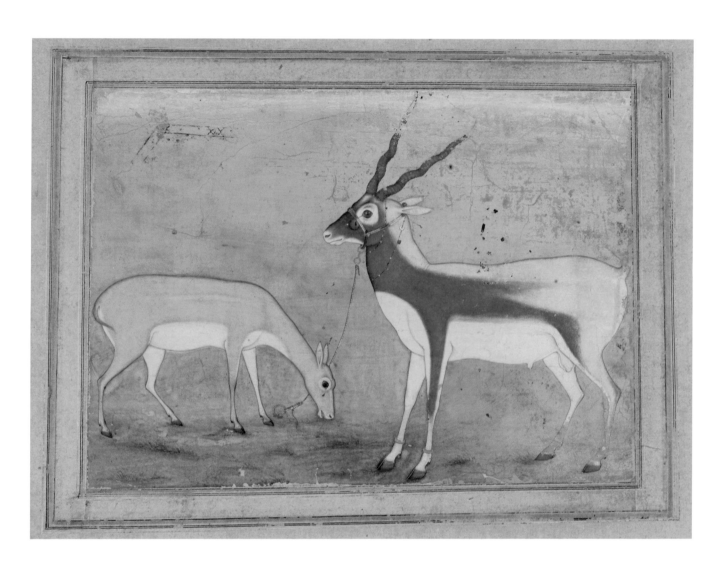

Anonymous artist of the Mughal School
(Indian, late Shah Jehangir/early Shah Jehan period,
active ca. 1625–1650), *Two Royal Antelopes*, ca. 1625–
1650. Black ink, opaque watercolor, and gold,
16.3 × 21.2 cm (6⁷⁄₁₆ × 8⅜ in.). Bequest of Ruth Haas
Lilienthal, 1975.2.12

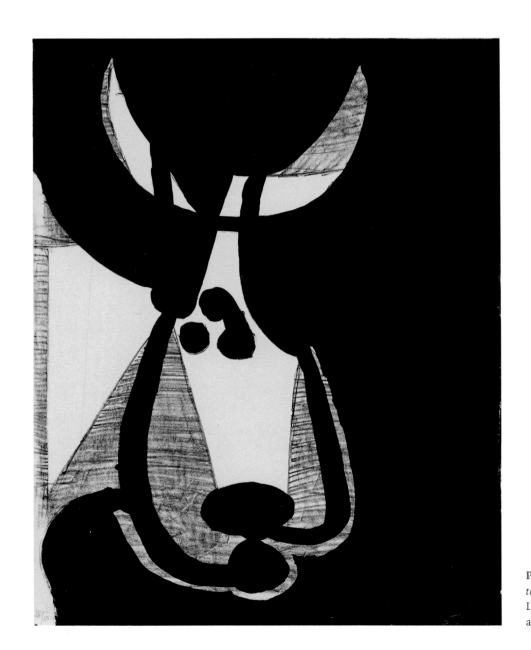

Pablo Picasso (Spanish, 1881–1973), *Tête de taureau, tournée à gauche* (*Bull's Head, Turned to the Left*), 1948. Lithograph, 64.5 × 49.7 cm (25⅜ × 19⁹⁄₁₆ in.). Bruno and Sadie Adriani Collection, 1971.28.78

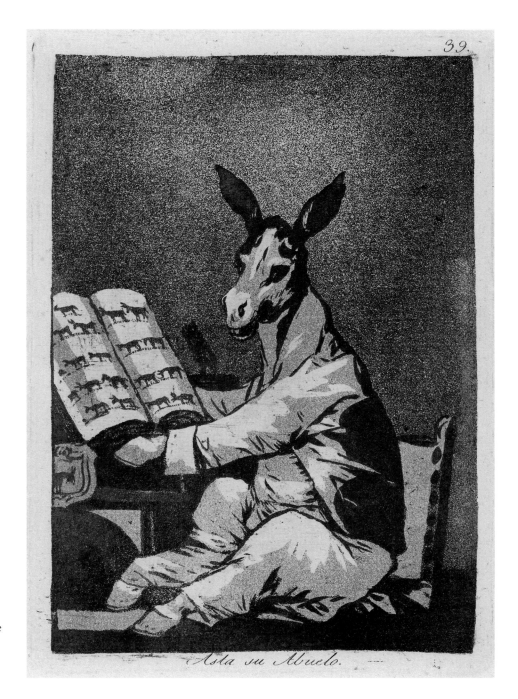

Asta su Abuelo.

Francisco de Goya (Spanish, 1746–1828), *Asta su abuelo (And So Was His Grandfather)*, plate 39 from the series *Los caprichos* (*Caprices*), 1799. Aquatint, 21.5 × 15.1 cm (8⁷⁄₁₆ × 5¹⁵⁄₁₆ in.). Gift of Mrs. Philip N. Lilienthal Jr., 1971.36.39

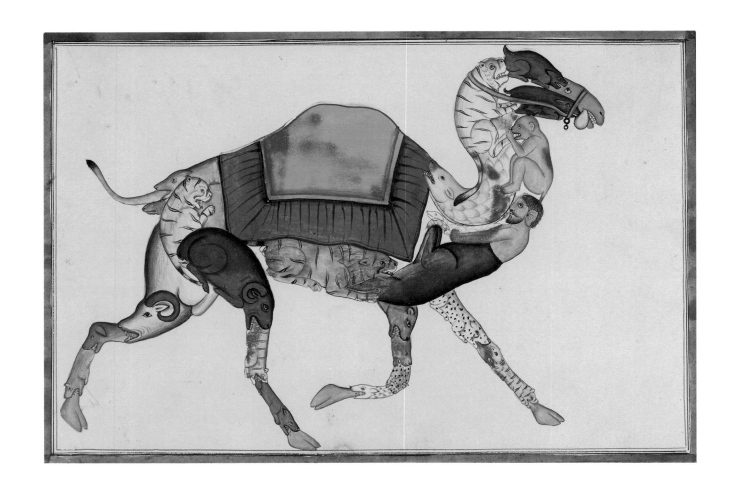

Anonymous artist of Rajasthani and Company School (Indian, Rajput, active 19th century), *Composite Camel*, 19th century. Black ink and opaque and transparent watercolors, 18 × 25.1 cm (7¹⁄₁₆ × 9⅞ in.). Achenbach Foundation for Graphic Arts, 1963.24.694

The subgenre of composite animals derives from the so-called animal style of art and dates as early as the first millennium BC. Very little is understood about the meanings of these works, however, and today such creations are admired primarily for the artists' curious and intelligent juxtapositions. Here various animals of India contribute to the overall form of a camel.

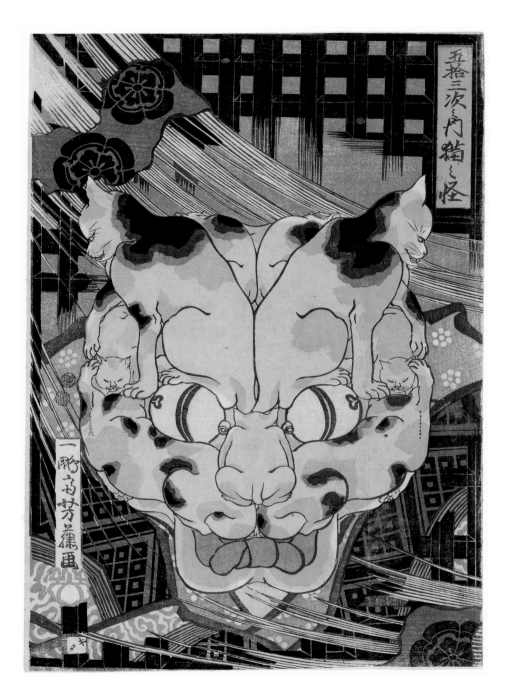

Utagawa Yoshifuji (Japanese, 1828–1887), *The Supernatural Cat of the Tōkaidō*, 1847–1852. Color woodcut, 36.7 × 25.2 cm (14⁷⁄₁₆ × 9¹⁵⁄₁₆ in.). Museum purchase, Achenbach Foundation for Graphic Arts Endowment Fund, 1991.1.120

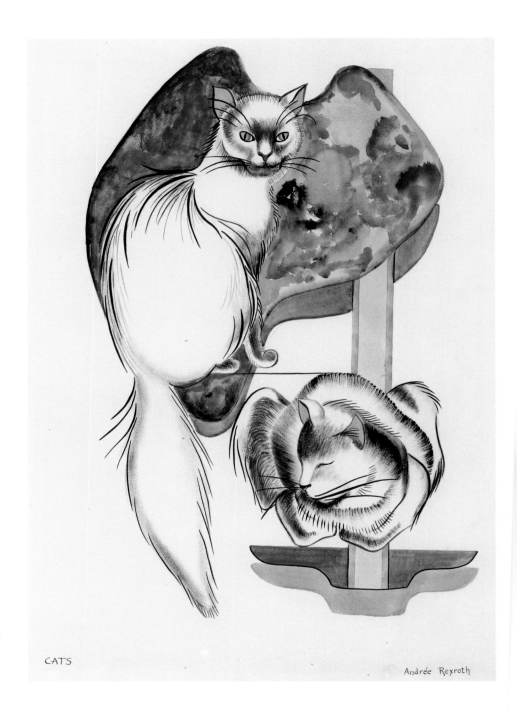

CATS

Andrée Rexroth

Andrée Schafer Rexroth (American, 1902–1940), *Cats*, ca. 1935–1940. Watercolor, 68 × 49.8 cm (26¾ × 19⅝ in.). Allocated by the Federal Art Project, L43.2.922

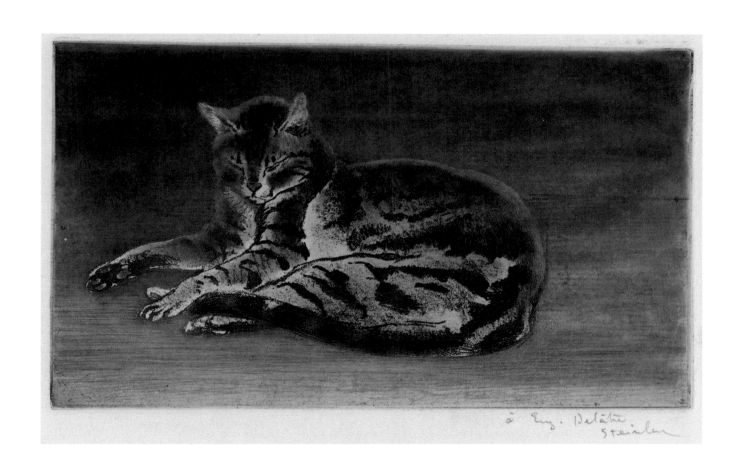

Théophile Alexandre Steinlen (Swiss, active in France, 1859–1923), *Chat sur le plancher* (*Cat on the Floor*), 1902. Color aquatint, etching, and soft-ground etching, 15.1 × 25.5 cm (5¹⁵⁄₁₆ × 10¹⁄₁₆ in.). Museum purchase, Achenbach Foundation for Graphic Arts Endowment Fund, 1965.68.6

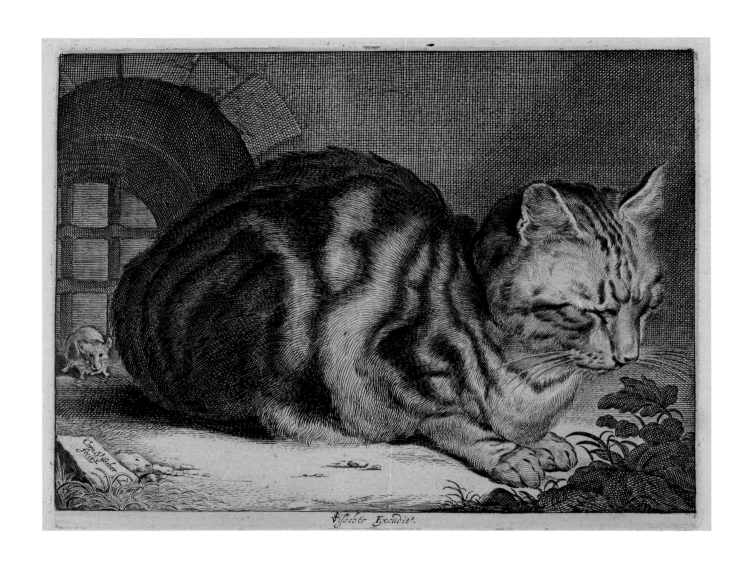

Cornelis Visscher (Dutch, ca. 1629–1658), *The Large Cat*, 1657. Engraving, 14.4 × 18.6 cm (5¹¹⁄₁₆ × 7⁵⁄₁₆ in.). Published by Claes Jansz Visscher. Museum purchase, Achenbach Foundation for Graphic Arts Endowment Fund, 1967.22.13

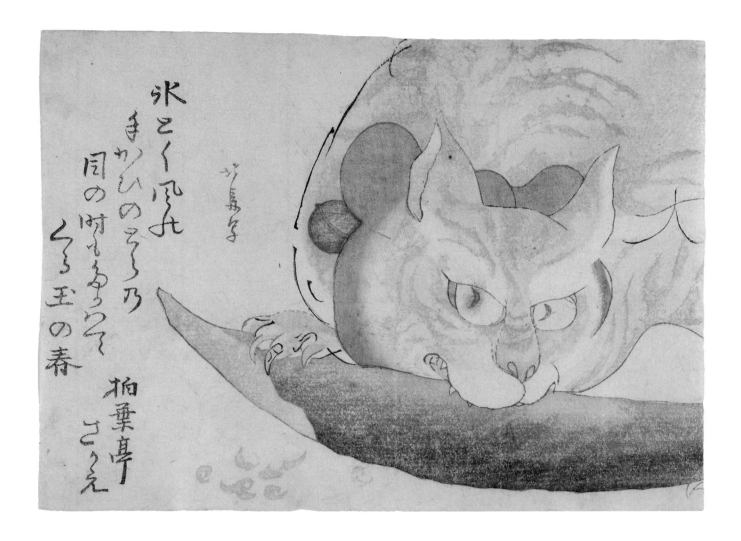

Teisai Hokuba (Japanese, 1771–1844), *A Cat with a Red Silk Ribbon Eating a Piece of Fish*, ca. 1820. Color woodcut *surimono* with metallic pigments and embossing, 13.8 × 19 cm (5⁷⁄₁₆ × 7½ in.). Museum purchase, Achenbach Foundation for Graphic Arts Endowment Fund, Dr. and Mrs. Donald Heyneman Fund, and the Prints and Drawings Art Trust Fund, 1993.13

Surimono were woodblock prints that were often made to be distributed as greetings in the New Year, and many functioned as picture-calendars; in this print, numerals referring to the long and short months of the lunar calendar are discreetly incorporated into the body of the cat.

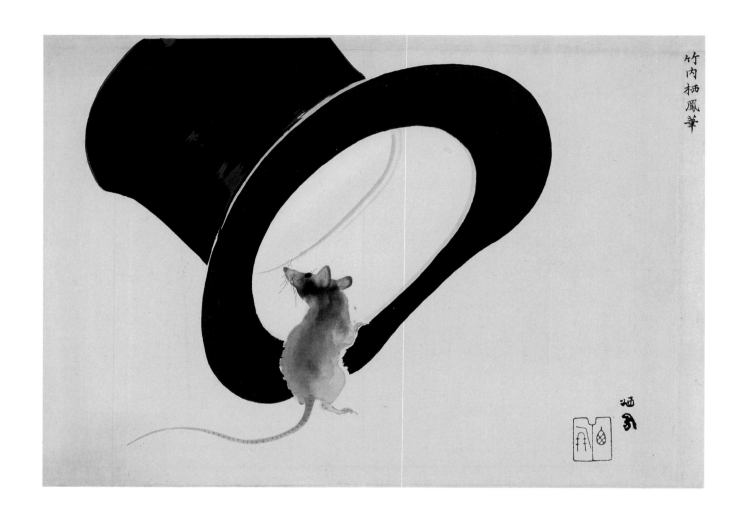

竹内栖鳳筆

Takeuchi Seihō (Japanese, 1864–1942), *Rat and Top Hat*, ca. 1910. Color woodcut, 36.1 × 51.8 cm (14³⁄₁₆ × 20³⁄₈ in.). Museum purchase, Achenbach Foundation for Graphic Arts Endowment Fund, 1992.65

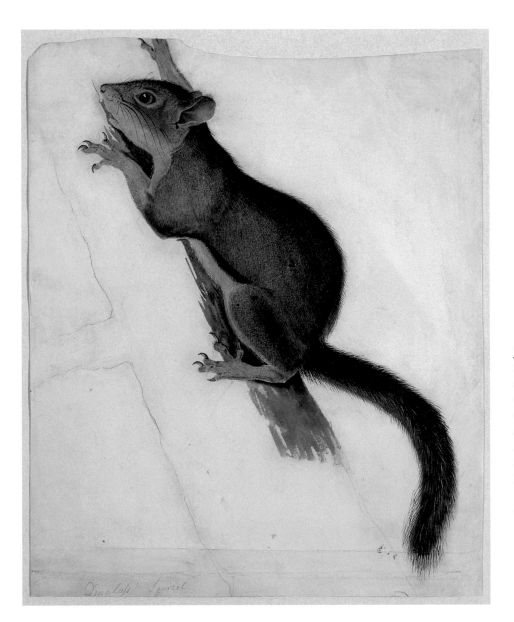

John James Audubon (American, b. Santo Domingo [now Haiti], 1785–1851), *Douglass' Squirrel*, study for plate 48 in the book *The Viviparous Quadrupeds of North America* by John James Audubon and Rev. John Bachman (New York: John James Audubon, 1845–1848), ca. 1843. Watercolor, ink, graphite, and glaze, 31 × 24.2 cm (12³⁄₁₆ × 9½ in.), irregular. Gift of Mr. and Mrs. John D. Rockefeller 3rd, 1979.7.5

American naturalist John James Audubon was deeply committed to the marriage of art and science, taking painstaking efforts to ensure that his watercolor studies of dead specimens shared the vitality of his subjects when they were alive in the wild.

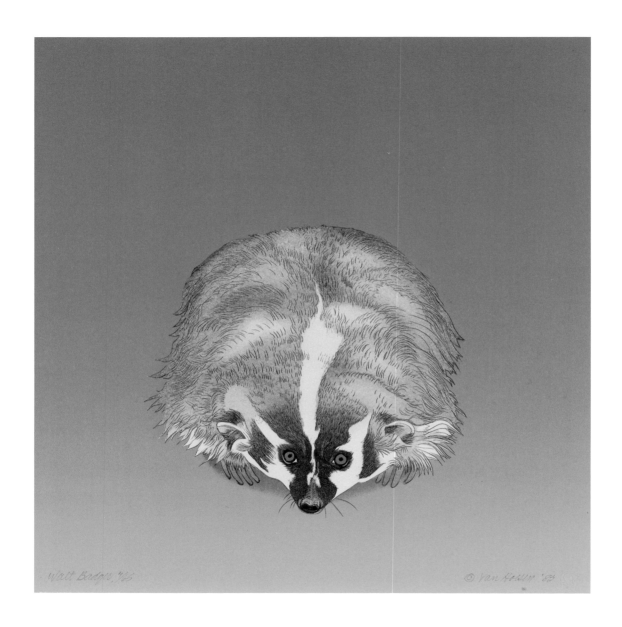

Beth Van Hoesen (American, 1926–2010), *Walt Badger*,
1982. Color lithograph, 39.4 × 38.3 cm (15½ × 15¹⁄₁₆ in.).
Printed by Terry Rein, Trillium Graphics, Brisbane,
California. Gift of the artist, 1982.1.128

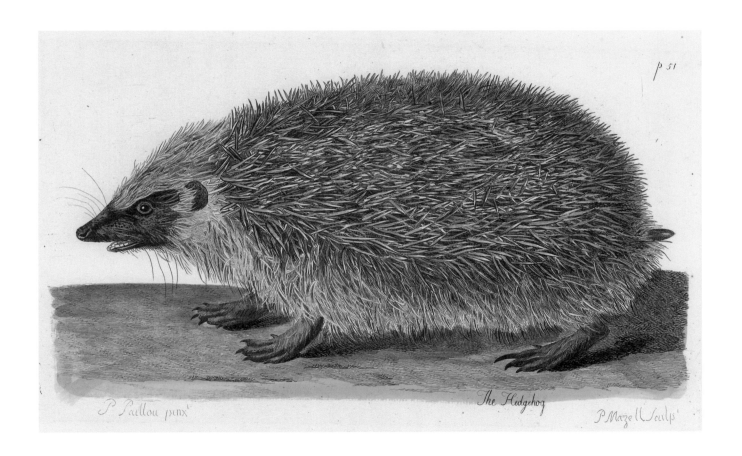

P. Paillou pinx.ᵗ The Hedgehog *P. Mazell sculp.ᵗ*

Peter Mazell (Irish, active 1761–1797), after
Peter Paillou (English, active ca. 1745–ca. 1806),
The Hedgehog, in the book *The British Zoology* by
Thomas Pennant (London: J & J March, 1766).
Etching with hand coloring, 18.9 × 31.2 cm (7⁷⁄₁₆ ×
12⁵⁄₁₆ in.). Achenbach Foundation for Graphic Arts,
1963.30.1468c

Books like Thomas Pennant's *The British Zoology* were among the primary
ways for a wide populace to learn about the traits of curious and unknown
animals. Pennant's entry on the hedgehog describes the creature in great
detail, concluding with a summary of its manner: "It is a mild, helpless, and
patient animal; and would be liable to injury from every enemy, had not
providence guarded it with a strong covering; and a power of rolling itself
into a ball."

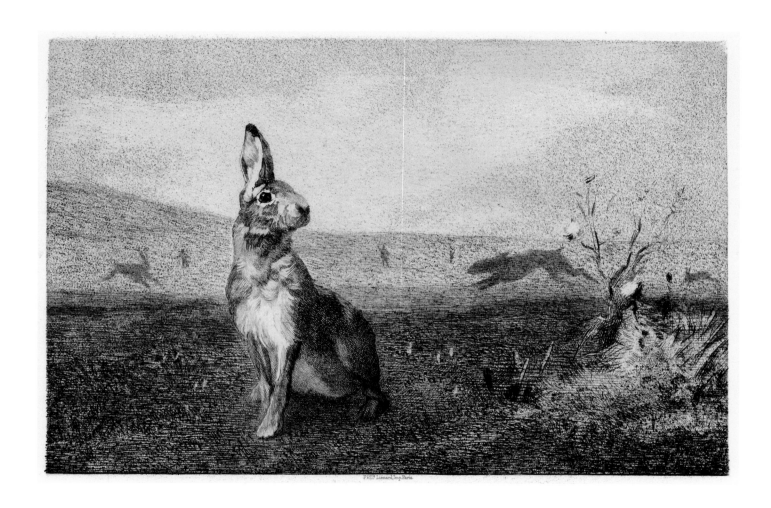

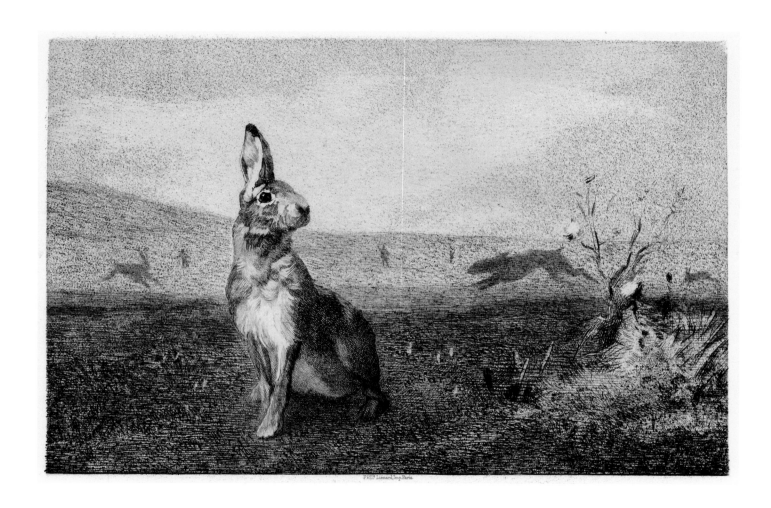 F Not. Lienard,Imp.Paris.

Félix Bracquemond (French, 1833–1914), after
Albert de Balleroy (French, 1828–1873), *Le lièvre* (*The Hare*), 1872. Etching, 17.9 × 25.2 cm (7⅟₁₆ × 9¹⁵⁄₁₆ in.).
Gift of Dr. Ludwig A. Emge, 1971.17.51

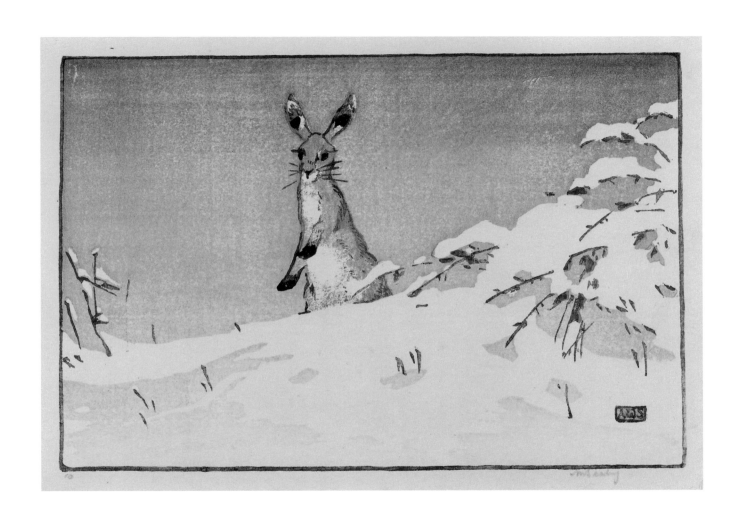

Allen William Seaby (English, 1867–1953), *Hare in Snow*, ca. 1923. Color woodcut on Japanese paper, 12.1 × 17.5 cm (4¾ × 6⅞ in.). Gift of Miss H. Dorothy Tilly in memory of Margaret Tilly, 1969.43.7

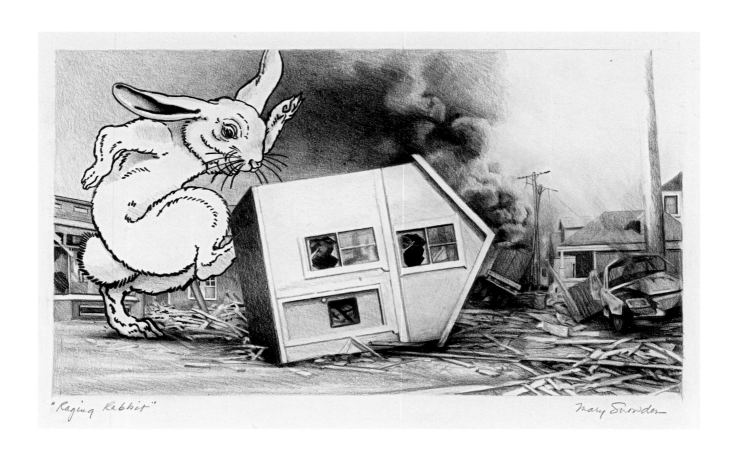

"Raging Rabbit" Mary Snowden

Mary Snowden (American, b. 1940), *Raging Rabbit*,
2003. Colored pencil, 37.8 × 57.8 cm (14⅞ × 22¾ in.).
Museum purchase, Jean Dinkelspiel Benatar Fund
and Innis Bromfield Fund, 2004.48

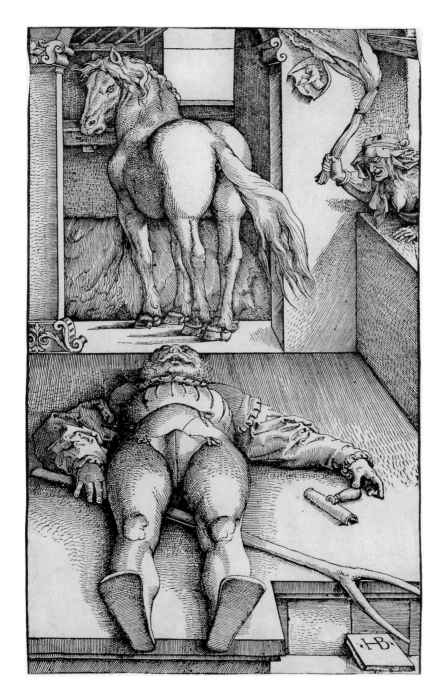

Hans Baldung (German, 1484–1545), *The Bewitched Groom*, ca. 1544. Woodcut, 34.2 × 19.9 cm (13⁷⁄₁₆ × 7¹³⁄₁₆ in.), cropped within image. Bequest of Ruth Haas Lilienthal, 1975.1.80

In this curious composition Hans Baldung left unspecified the role of the mare in the groom's fall, but it seems that the horse has turned on its handler, perhaps so bidden by the witch at the window.

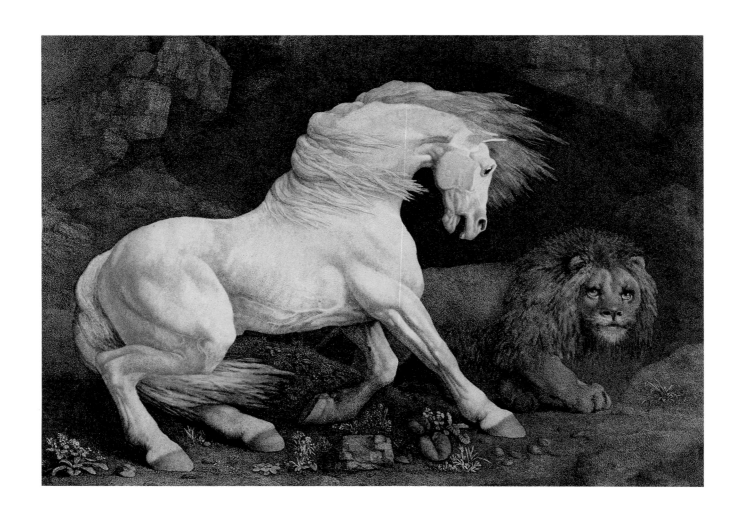

George Stubbs (English, 1724–1806), *A Horse Frightened by a Lion*, 1788. Etching with roulette, 25.4 × 33.1 cm (10 × 13¹⁄₁₆ in.), cropped within plate mark. Published by George Stubbs. Museum purchase, gift of the Graphic Arts Council in memory of Jim Hahn, 2003.72.1

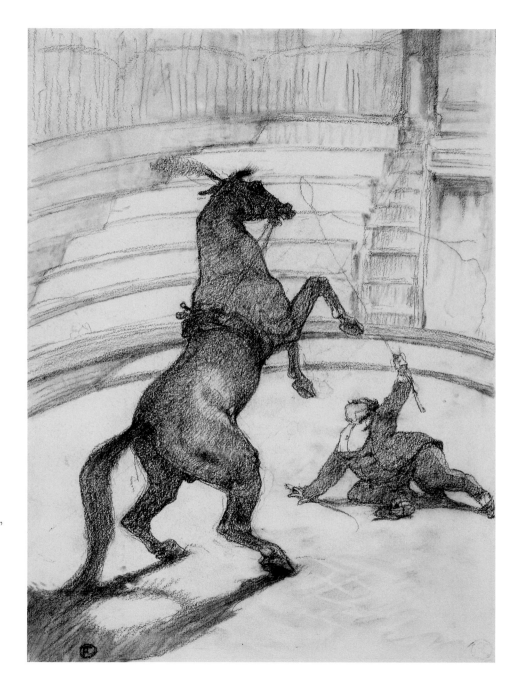

Henri de Toulouse-Lautrec (French, 1864–1901), *Au cirque: Cheval pointant* (*At the Circus: Rearing Horse*), 1899. Black chalk with orange and yellow pencil additions, 35.7 × 25.4 cm (14¹/₁₆ × 10 in.). Museum purchase, Elizabeth Ebert and Arthur W. Barney Fund, 1977.2.5

While undergoing treatment in a sanatorium on the outskirts of Paris in 1899, Henri de Toulouse-Lautrec turned his hand to drawings of the circus, creating compositions such as this one entirely from memory.

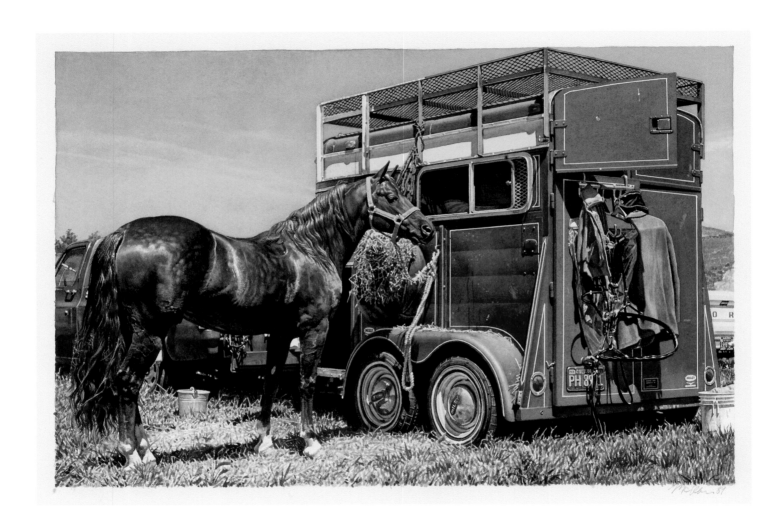

Richard McLean (American, b. 1934), *Vacaville Chestnut*, 1989. Watercolor, 38.7 × 52.9 cm (15¼ × 20¹³⁄₁₆ in.). Gift of John Berggruen Gallery, San Francisco, 1992.83.2

Renowned photorealist painter Richard McLean works from photographs that he takes during his travels. He is best known for his paintings of horses.

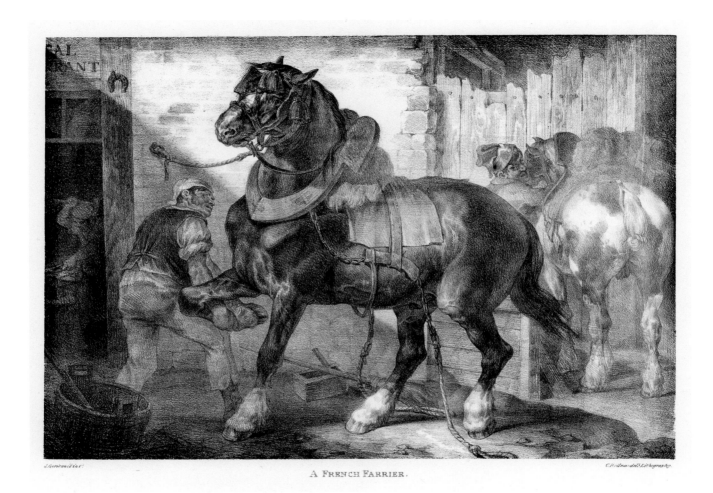

A FRENCH FARRIER.

Théodore Géricault (French, 1791–1824), *A French Farrier*, plate 12 from the series *Various Subjects Drawn from Life on Stone*, 1821. Lithograph, 24.6 × 35.5 cm (9¹¹⁄₁₆ × 14 in.). Printed by Charles Joseph Hullmandel. Gift of Mr. and Mrs. Edgar Sinton, 1961.55.2

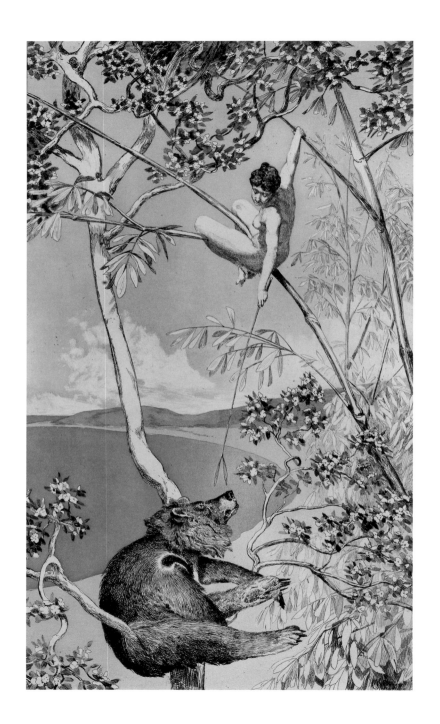

Max Klinger (German, 1857–1920), *Bär und Elfe*
(*Bear and Fairy*), 1880, plate 1 from the portfolio
Intermezzi, 1881. Etching and aquatint on chine
collé, 42 × 28.2 cm (16⁹⁄₁₆ × 11⅛ in.). Achenbach
Foundation for Graphic Arts, 1963.30.1555.1

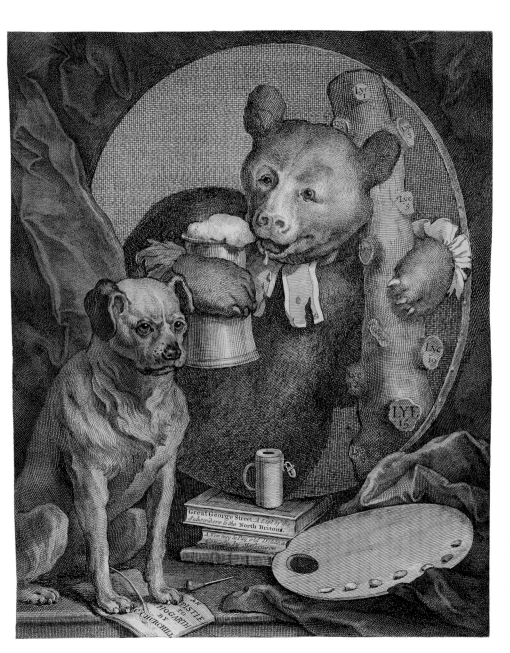

William Hogarth (English, 1697–1764), *The Bruiser*, 1763. Etching and engraving, 36.7 × 27 cm (14⁷⁄₁₆ × 10⁵⁄₈ in.), cropped within plate mark. Achenbach Foundation for Graphic Arts, 1963.30.1517

By 1763 esteem for the social critique that William Hogarth offered throughout his modern moral subjects was in decline, his influence largely overshadowed by the writings of the clergyman Charles Churchill. In this reworking of an earlier self-portrait, the artist replaced his own likeness with an unkempt bear clutching a large tankard of beer; his contemporaries would have recognized this as a satirical reference to Churchill.

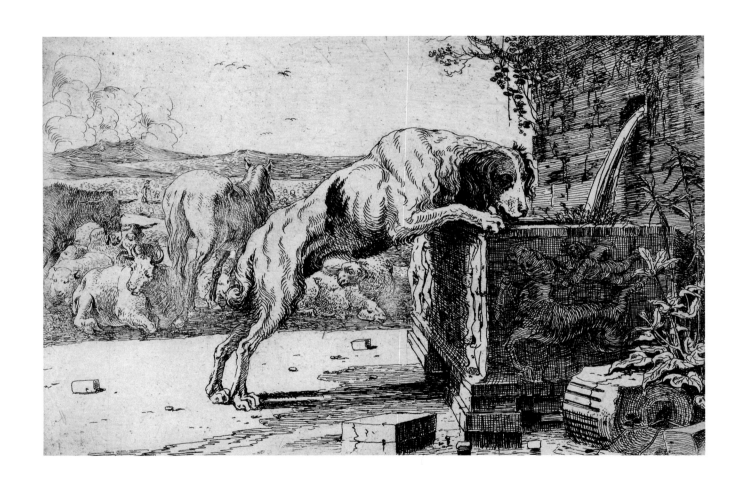

Jan van den Hecke the Elder (Dutch, 1620–1684),
Dog Drinking from a Fountain, from the series *The Set of
Animals*, 1656. Etching, 10.7 × 15.9 cm (4³⁄₁₆ × 6¼ in.).
Achenbach Foundation for Graphic Arts, 1963.30.15294

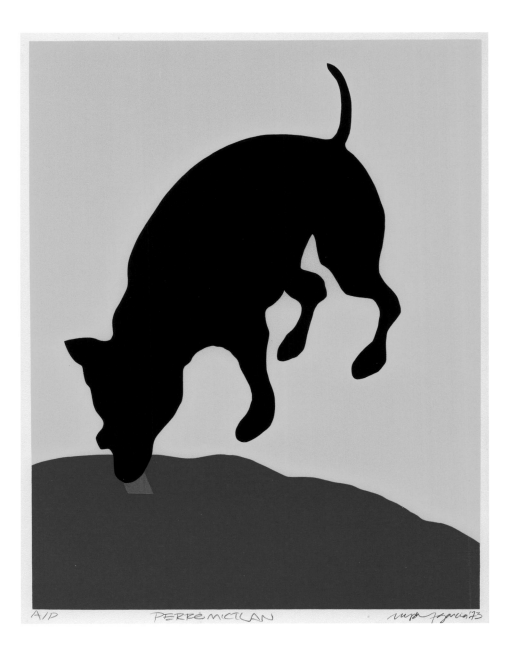

AIP PERRÉMICTLAN

Rupert Garcia (American, b. 1941), *Perromictlan*, 1973. Color screenprint, 63.3 × 48.4 cm (24¹⁵⁄₁₆ × 19¹⁄₁₆ in.). Gift of Mr. and Mrs. Robert Marcus, 1990.1.110

The title of this print refers to the ancient Aztec underworld and to the dog, or "soul-companion," that was destined to accompany the soul of the deceased on its tortuous journey from this world to the afterlife.

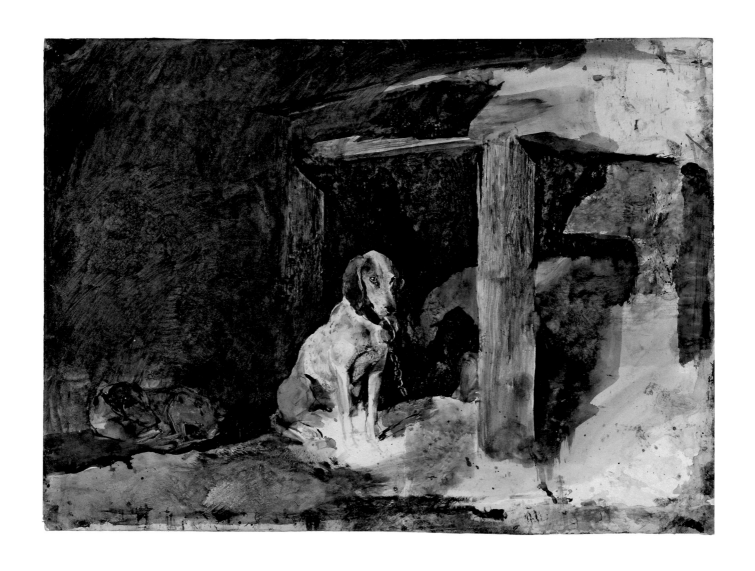

Andrew Wyeth (American, 1917–2009), *Coon Dog*,
ca. 1958. Watercolor, 53.3 × 71.1 cm (21 × 28 in.).
Bequest of Alletta Morris McBean, 2004.35.6

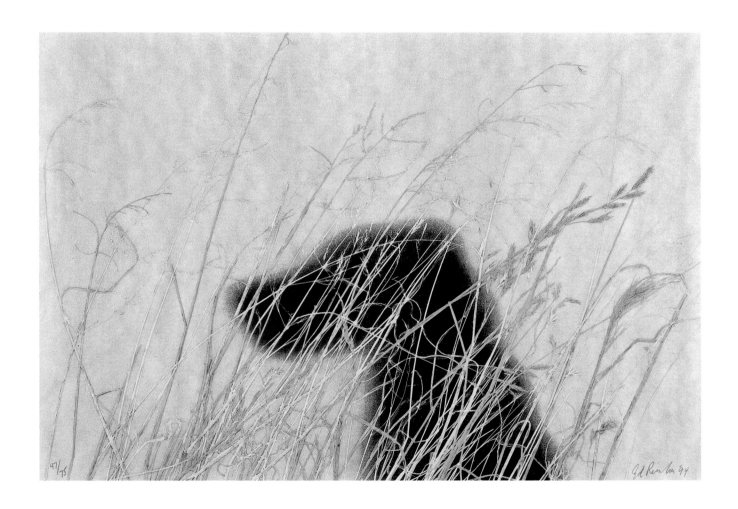

47/75

Ed Remba 94

Ed Ruscha (American, b. 1937), *Dog*, 1995. Mixografia on handmade paper, 69.2 × 97.8 cm (27¼ × 38½ in.). Printed by Luis Remba; published by Mixografia Workshop, Los Angeles. Anderson Graphic Arts Collection, gift of Mrs. Gunther R. Detert, Prints and Drawings Art Trust Fund, funds in memory of Suzanne Reger, Dr. Saliga Reger, Katharine Hanrahan, Jenicka Rosekrans, Allen Swayze, Edward C. "Chuck" Bassett, Pat Steger, John Langley Howard, Hilda Mary "Johnny" Danforth, Dorothy Munn, and other memorial funds, 2000.28

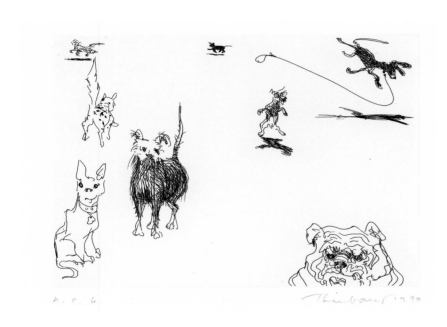

A. P. 6

Thiebaud 1990

Wayne Thiebaud (American, b. 1920), *Eight Dogs*,
1990. Etching, 12.5 × 17.6 cm (4¹⁵⁄₁₆ × 6¹⁵⁄₁₆ in.).
Printed by Lawrence Hamlin; published by Crown
Point Press, San Francisco. Crown Point Press
Archive, gift of Crown Point Press, 1992.167.219

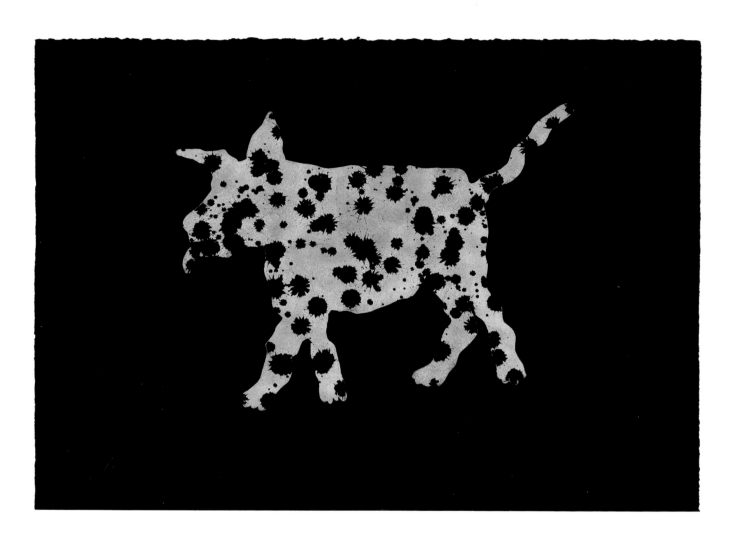

David James Gilhooly (American, b. 1943),
My Dog Spot, 1986. Lithograph printed in silver
leaf on black paper, 36 × 46 cm (14³⁄₁₆ × 18⅛ in.).
Published by Magnolia Editions, Oakland. Jeanne
Gantz Collection, gift of the Goldyne family,
1988.1.40

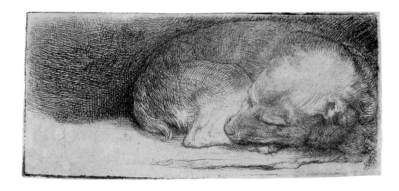

Rembrandt van Rijn (Dutch, 1606–1669), *Sleeping Puppy*, ca. 1640. Etching and drypoint, 3.9 × 8.3 cm (1⁹⁄₁₆ × 3¼ in.). Gift of Michael G. Berolzheimer in memory of Michael Berolzheimer, 1998.201.32

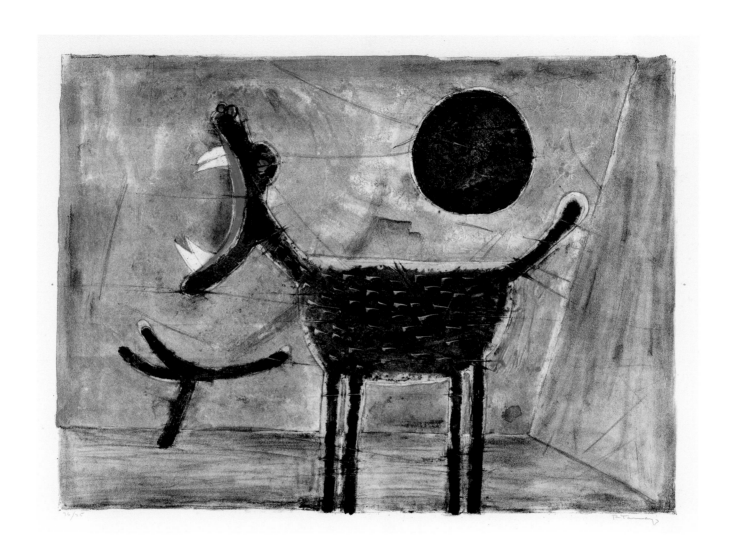

Rufino Tamayo (Mexican, 1899–1991), *Perro aullando*
(*Howling Dog*), 1960. Color lithograph, 50 × 65.5 cm
(19¹¹⁄₁₆ × 25¹³⁄₁₆ in.). Gift of Marvin Small, 1961.68.3

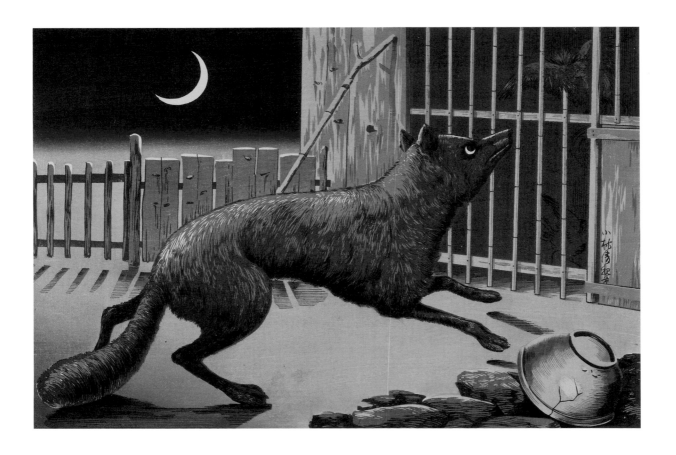

Kobayashi Kiyochika (Japanese, 1847–1915), *Fox and Crescent Moon*, 1880. Color woodcut, 24.2 × 34.9 cm (9½ × 13¾ in.). Museum purchase, Achenbach Foundation for Graphic Arts Endowment Fund, 1968.13.18

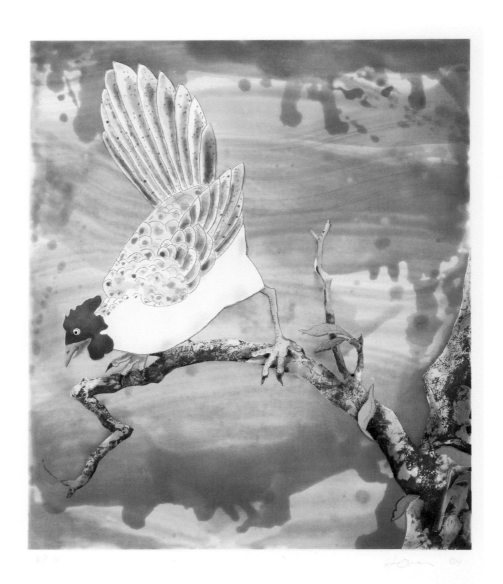

Laura Owens (American, b. 1970), *Untitled (LO270)*,
2004. Color spit-bite and soap-ground aquatints
with aquatint and soft-ground etching, 61 ×
50.8 cm (24 × 20 in.). Printed by Dena Schuckit;
published by Crown Point Press, San Francisco.
Crown Point Press Archive, gift of Crown Point
Press, 2006.18.6.1

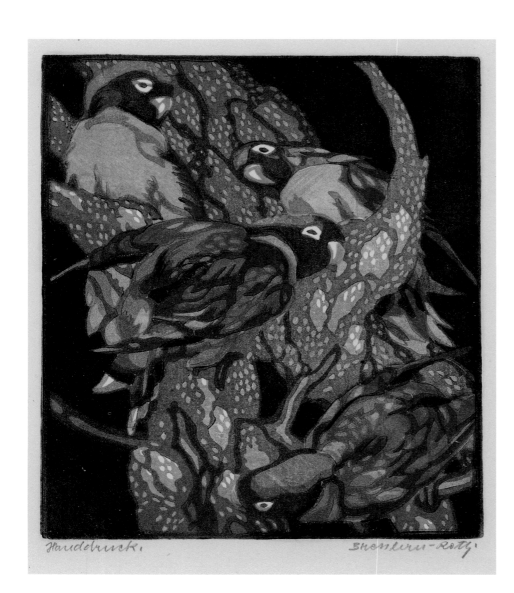

Handdruck. Bresslern-Roth.

Norbertine Bresslern-Roth (Austrian, 1891–1978),
Papageien (*Parrots*), ca. 1920s. Color linocut, 17.3 ×
15.3 cm (6¹³⁄₁₆ × 6 in.). Achenbach Foundation for
Graphic Arts, 1963.30.2722

Susan Middleton (American, b. 1948), *Requiem*, 2008. Color photogravure, 52.1 × 41.9 cm (20½ × 16½ in.). Printed by Asa Muir-Harmony; published by Crown Point Press, San Francisco. Crown Point Press Archive, gift of Crown Point Press, 2010.39.11.5

Requiem offers a portrait of a museum specimen, one example of a species of passenger pigeon that was once among the most plentiful creatures on earth, but that has been extinct for nearly a century.

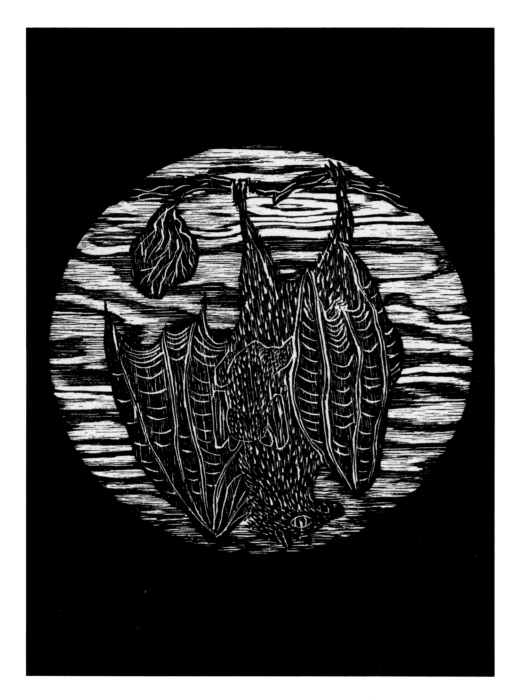

Kiki Smith (American, b. Germany, 1954), *Bat*, in the book *Bestiary* by Bradford Morrow (New York: Grenfell Press, 1990). Woodcut and linocut, 37.8 × 27.5 cm (14⅞ × 10¹³⁄₁₆ in.). Gift of the Reva and David Logan Foundation, 2000.200.19.36

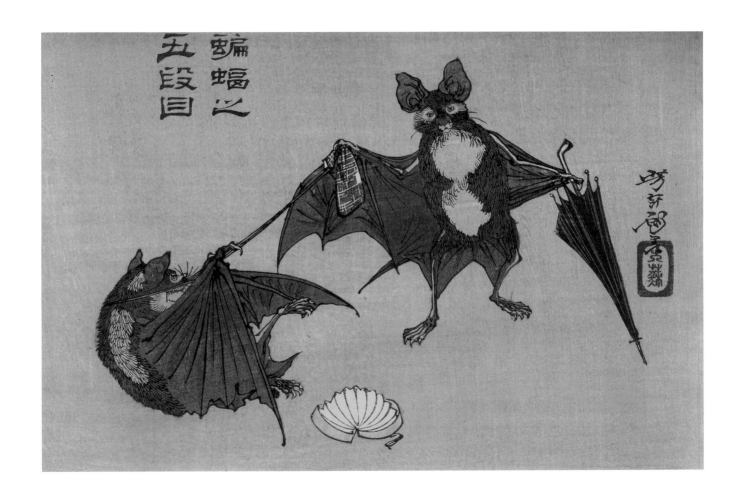

Tsukioka Yoshitoshi (Japanese, 1839–1892), *Kōmori no godanme* (*Bats in the Fifth Act of "Chūshingura"* [*Treasury of Loyal Retainers*]), from an untitled series known as *Yoshitoshi ryakuga* (*Sketches by Yoshitoshi*), early 1880s. Color woodcut, 16.7 × 24.2 cm (6⁹⁄₁₆ × 9½ in.). Museum purchase, George Henry Cabaniss Jr. Fund, 1985.1.25

Replacing dramatic kabuki actors with bats, Tsukioka Yoshitoshi offered a parody of the well-known *Chūshingura*, a play that was a popular subject for *ukiyo-e* prints.

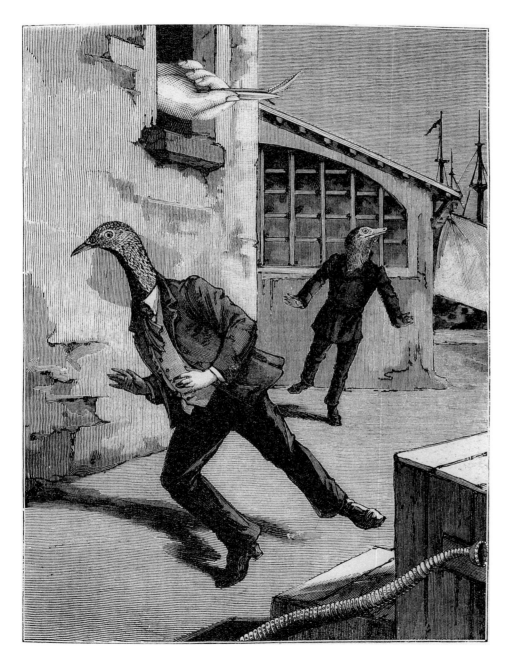

Max Ernst (French, b. Germany, 1891–1976), *Untitled*, illustration 7 in the fourth notebook (volume 4 of 5) of *Une semaine de Bonté ou les sept éléments capitaux* (Paris: Éditions Jeanne Bucher, 1934). Line-block reproduction, after collage of steel engraving, 19.5 × 14.3 cm (7¹¹⁄₁₆ × 5⅝ in.). Printed by George Duval, Paris. Museum purchase, Reva and David Logan Collection of Illustrated Books, Reva and David Logan Fund, 2001.16.4.7

In this multivolume work Max Ernst combined images sourced from Victorian books and encyclopedias to create a dark and surreal world where bird and human forms converge.

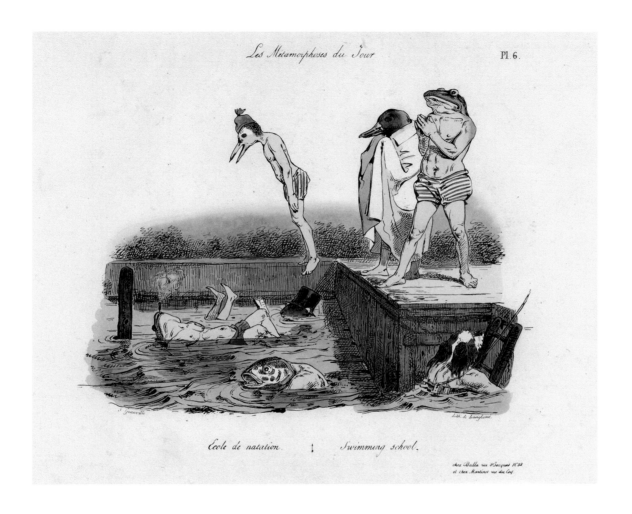

École de natation. ¦ Swimming school.

chez Bulla rue St Jacques N.38
et chez Martinet rue du Coq.

Grandville (Jean Ignace Isidore Gérard) (French, 1803–1847), *École de natation* (*Swimming School*), from the series *Les métamorphoses du jour* (*The Metamorphoses of the Day*), 1829. Lithograph with hand coloring, 19.4 × 20.1 cm (7⅝ × 11⁷⁄₁₆ in.). Printed by Langlumé, Paris; published by Martinet-Hautecoeur, Paris, and Antoine Bulla, Paris. Museum purchase, Achenbach Foundation for Graphic Arts Endowment Fund, 1982.1.26

With naturalistic rendering abilities that rivaled those of any scientifically inclined artist, Grandville used animal-human hybrid forms to critique human behavior.

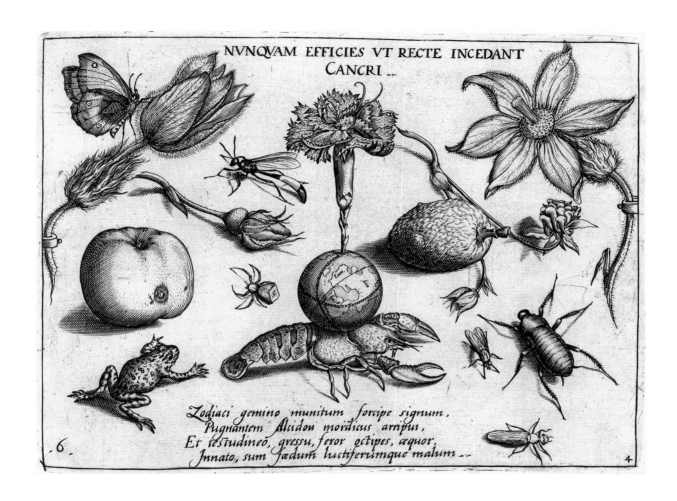

Jacob Hoefnagel (Flemish, 1575–ca. 1630), after **Joris Hoefnagel** (Flemish, 1542–1600), *Nvnqvam efficies vt recte incedant cancri . . .* (*Never will you make crabs walk upright . . .*), plate 6 in part 4 of the book *Archetypa studiaque patris Georgil Hoefnagelil* (*Archetypes and Studies by Joris Hoefnagel*) (Frankfurt: n. p., 1592). Engraving, 15.2 × 20.7 cm (6 × 8⅛ in.). Achenbach Foundation for Graphic Arts, 1963.30.38736.38

One of the first artists to find fascination in depicting bugs, Joris Hoefnagel studied many of these creatures with the help of magnification, in his time a little-used aid. The book from which this print derives became a standard resource for seventeenth-century still-life artists and spread advanced knowledge throughout the Western world.

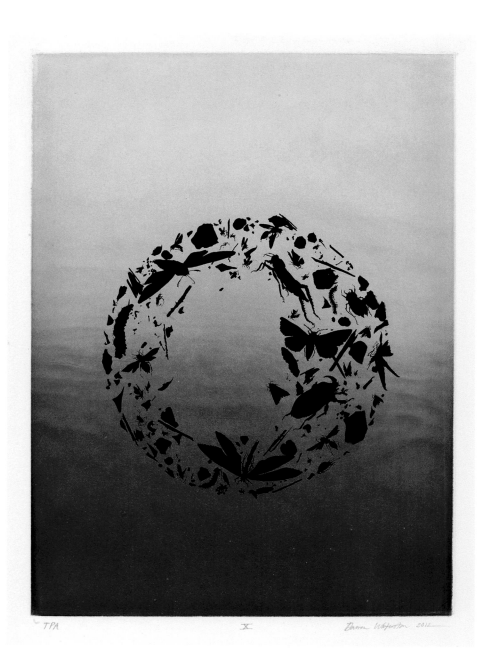

TPA X Darren Waterston 2012

Darren Waterston (American, b. 1965),
Plate X, 2012, from the portfolio *A Swarm, A Flock,
A Host: A Compendium of Creatures*, 2013. Etching,
aquatint, spit-bite aquatint, and water-bite
aquatint, 35.9 × 26 cm (14⅛ × 10¼ in.). Printed by
Reneé Bott, Paulson Bott Press, San Francisco;
published by the Achenbach Graphic Arts Council,
San Francisco. Courtesy of the artist and the
Achenbach Graphic Arts Council

Odilon Redon (French, 1840–1916), *Araignée*
(*Spider*), 1887. Lithograph on chine collé, 28 ×
21.6 cm (11 × 8½ in.). Printed by Lemercier et Cie,
Paris. Museum purchase, Achenbach Foundation
for Graphic Arts Endowment Fund and the Ian
White Endowment Income Fund, 1996.178

The renowned Symbolist artist Odilon Redon visited
natural history museums and drew countless accurate
studies of spiders, so he was certainly aware that the
arachnid possesses eight legs. Nonetheless, in this
lithograph he endowed his happy spider with ten,
making evident the pleasure that he took in creating
and bringing to life "improbable beings."

Ed Ruscha (American, b. 1937) and **Ken Price** (American, 1935–2012), *Flies and Frog*, 1969. Color lithograph, 59.1 × 86.4 cm (23¼ × 34 in.). Printed by Daniel Socha; published by Tamarind Lithography Workshop Inc., Los Angeles. Museum purchase, Mrs. Paul L. Wattis Fund, 2000.131.8.1

In this collaboration between Ed Ruscha and Ken Price, each artist approached his subject with his distinct signature style: Ruscha rendered the mass of flies with nearly trompe-l'oeil precision, and Price evoked Pop Art with his frog.

Wes Wilson (American, b. 1937) and **Heinrich Kley** (German, 1863–1945), *Bill Graham Presents in Dance-Concert the Turtles . . .* , 1966. Color lithograph, 50.4 × 35.2 cm (19¹³⁄₁₆ × 13⁷⁄₈ in.). Printed by West Coast Lithograph Co., San Francisco. Museum purchase, Achenbach Foundation for Graphic Arts Endowment Fund, 1972.53.43

Wes Wilson designed this poster, which advertises a concert by the legendary American rock band the Turtles, appropriating the whimsical turtle images from drawings by the German caricaturist and editorial cartoonist Heinrich Kley.

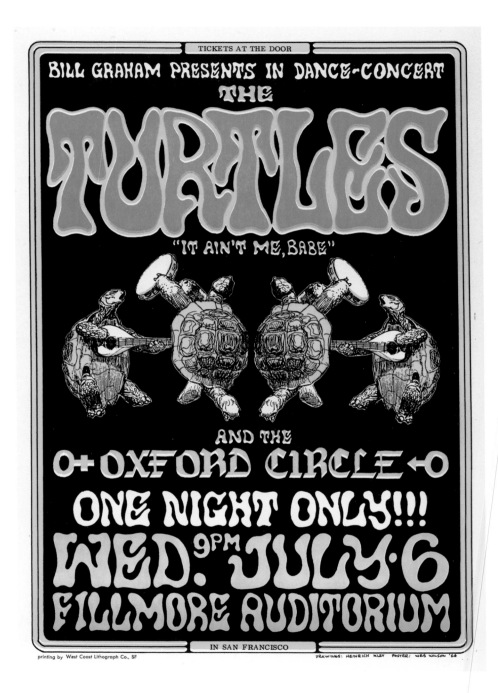

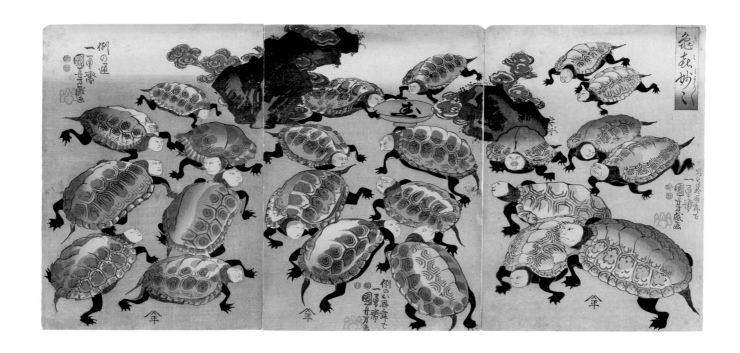

Utagawa Kuniyoshi (Japanese, 1797–1861),
Kabuki Actors as Turtles, 1848. Color woodcut triptych,
each sheet approximately 35.6 × 24.9 cm (14 × 9¹³⁄₁₆ in.).
Museum purchase, Achenbach Foundation for Graphic
Arts Endowment Fund, 1981.1.190a–c

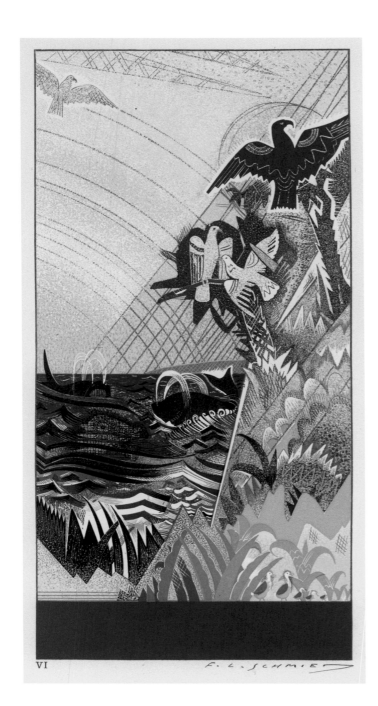

VI *F. L. SCHMIED*

François-Louis Schmied (Swiss, active France, 1873–1941), *Les mastodontes et les volants-oiseaux* (*The Mastodons and the Flying Birds*), plate 6 in the book *La création: Les trois premiers livres de la Genèse suivis de la généalogie Adamique* (*Creation: The First Three Books of Genesis Followed by Adam's Genealogy*), translated by Dr. J. C. Mardrus (Paris: F.-L. Schmied, 1928). Color wood engraving, 27.2 × 13.6 cm (10¹¹⁄₁₆ × 5⅜ in.). Museum purchase, funds from the Artist Book Council in honor of Reva and David Logan, 1998.3.13

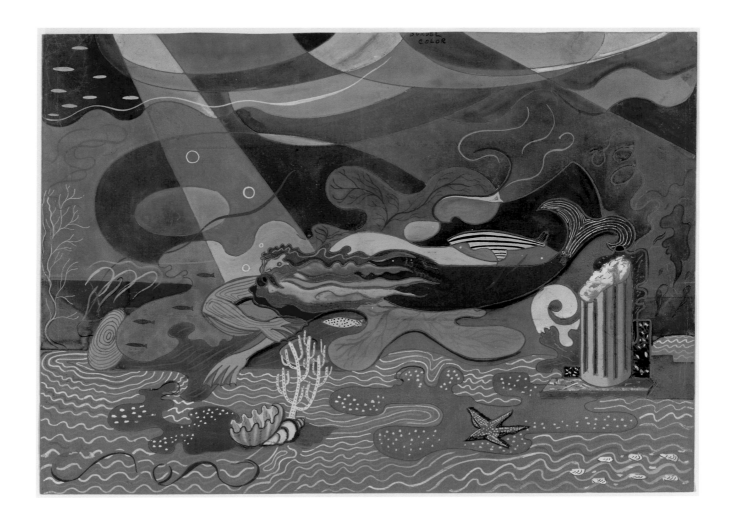

Hilaire Hiler (American, b. Paris, 1898–1966), *Design for a Mural, Aquatic Park Bathhouse*, ca. 1936–1937. Transparent and opaque watercolor, 45.2 × 62 cm (17¹³⁄₁₆ × 24⁷⁄₁₆ in.). Allocated by the Federal Art Project, L43.2.881

In a joint project between the city of San Francisco and the Works Progress Administration, Hilaire Hiler spent two years designing the interior murals for the city's Aquatic Park Bathhouse (today's Maritime Museum). Hiler filled his ocean floor with sea creatures and brightly colored fish who comingle with the submerged continents and ruins of the legendary Mu and Atlantis.

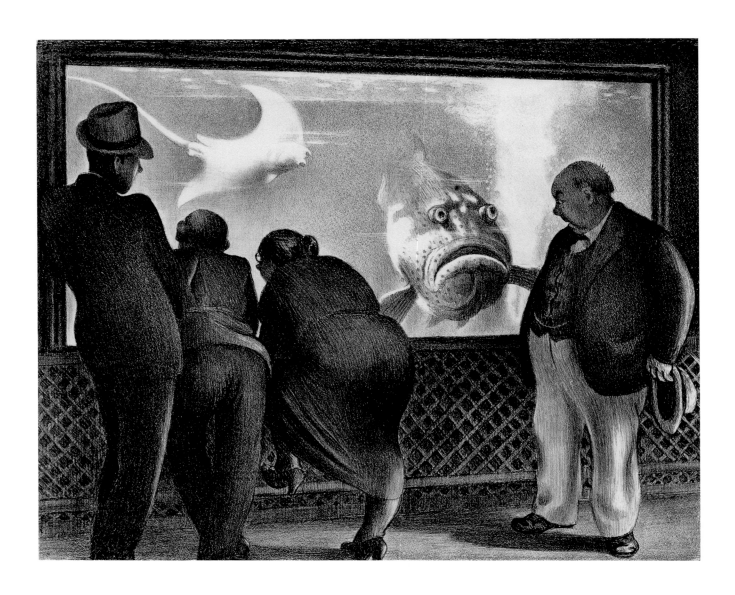

Mabel Dwight (American, 1876–1955), *Queer Fish*,
1936. Lithograph, 27.2 × 33.1 cm (10¹¹⁄₁₆ × 13¹⁄₁₆ in.).
Published by American Artists Group, New York.
Achenbach Foundation for Graphic Arts,
1963.30.3283

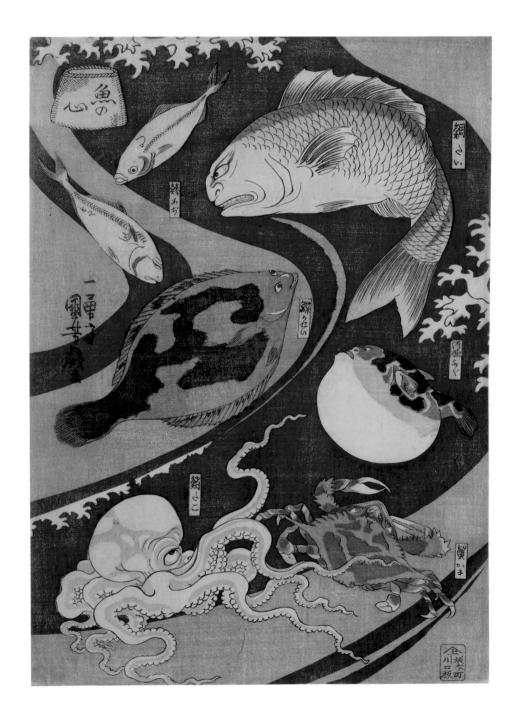

Utagawa Kuniyoshi (Japanese, 1797–1861), *Kabuki Actors as Fish*, 1842. Color woodcut, 35.7 × 24.4 cm (14¹¹⁄₁₆ × 9⅝ in.). Museum purchase, Achenbach Foundation for Graphic Arts Endowment Fund, 2006.109.4

In Utagawa Kuniyoshi's humorous print, the artist has given various sea creatures the faces of recognizable Kabuki actors; the sea bream refers to Nakamura Utaemon IV, the octopus represents Arashi Kanjūrō, and the blowfish resembles Onoe Tamizō II.

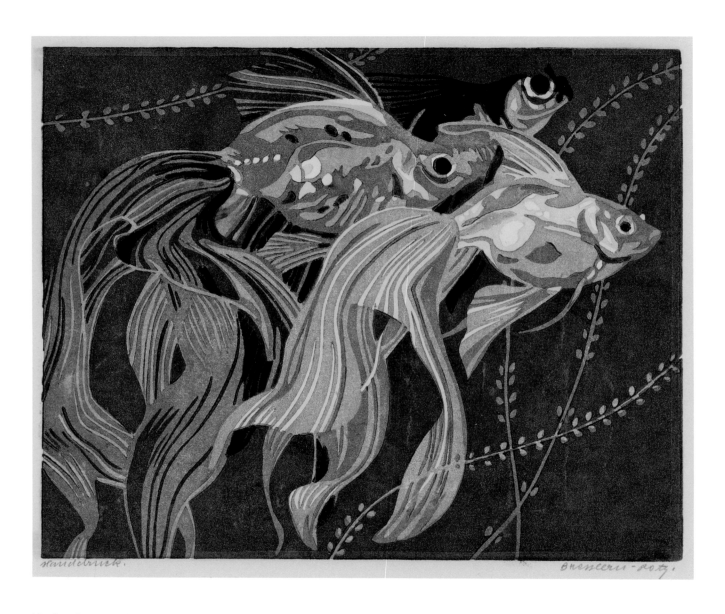

Norbertine Bresslern-Roth (Austrian, 1891–1978),
Schleierschwänze (Fantails), 1922. Color linocut, 20 ×
24.2 cm (7⅞ × 9½ in.). Achenbach Foundation for
Graphic Arts, 1963.30.2715

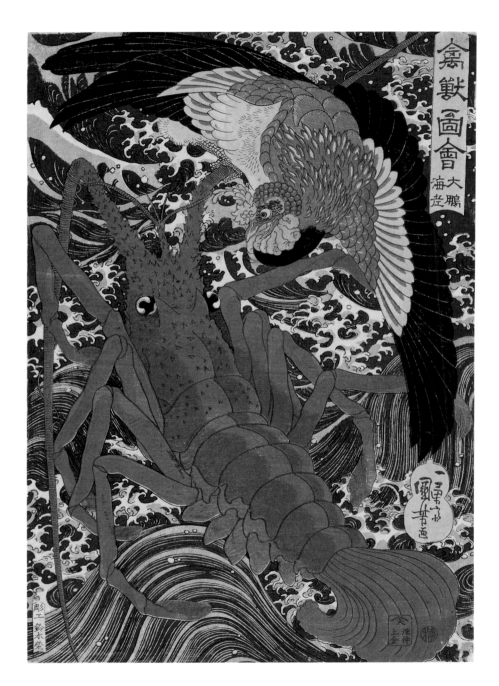

Utagawa Kuniyoshi (Japanese, 1797–1861),
Taihō, ebi (*Phoenix and Lobster*), from the series
Kinjū zue (*Birds and Beasts*), 1839–1841. Color
woodcut, 37.3 × 25.5 cm (14¹¹⁄₁₆ × 10¹⁄₁₆ in.). Museum
purchase, Achenbach Foundation for Graphic Arts
Endowment Fund, 1977.1.326

In a fourteenth-century Zen parable about the
incomprehensibility of metaphysical dimensions,
the monk Ikkyū told of a phoenix who rested after
a long flight south on the whisker of a giant lobster.
The lobster helped the bird further its journey but
eventually tired and took rest inside a cave that
turned out to be the ear of a giant turtle. The turtle
carried on, further south, and neither the phoenix
nor the lobster ever saw its homeland again.

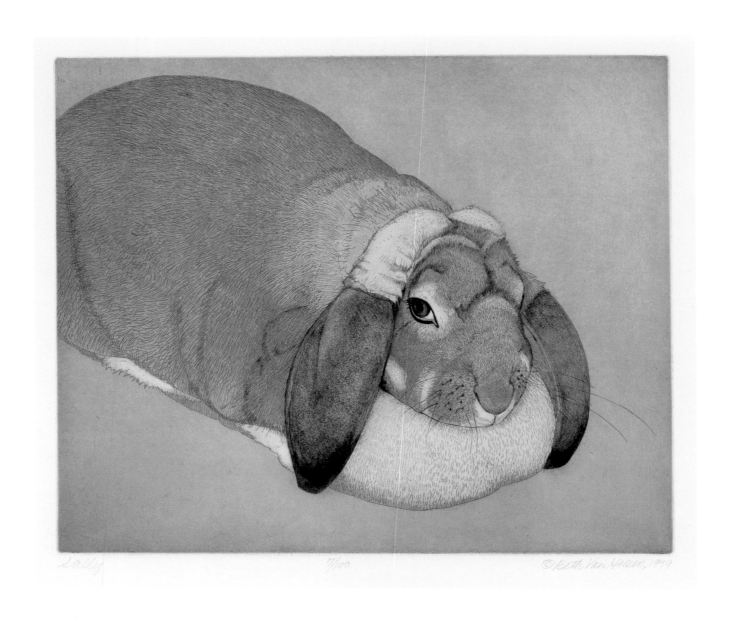

Beth Van Hoesen (American, 1926–2010), *Sally*,
1979/1981. Color aquatint, etching and drypoint,
29.3 × 35 cm (11⁹⁄₁₆ × 13¾ in.). Museum purchase,
Hamilton-Wells Fund, 1980.1.33

Index of Artworks

Fine Arts Museums of San Francisco
Golden Gate Park
50 Hagiwara Tea Garden Drive
San Francisco, CA 94118-4502
www.famsf.org • 415-750-3600

Leslie Dutcher: Director of Publications
Danica Hodge: Editor
Lucy Medrich: Associate Editor

Project Management by Danica Hodge
Copyedited by Lucy Medrich
Produced by Marquand Books, Seattle
Designed by Zach Hooker with assistance from Ryan Polich
Typeset by Brielyn Flones and Brynn Warriner
Printed and bound in China by Artron Color Printing Co.

Library of Congress Cataloging-in-Publication Data
Fine Arts Museums of San Francisco.
 Artful animals / Colleen Terry.
 pages cm
 Includes index.
 ISBN 978-0-88401-138-5
1. Animals in art. 2. Art—California—San Francisco. I. Terry,
Colleen M., author. II. Title.
 N7660.F48 2013
 704.9'43207479461—dc23
 2012045968

The Museums thank the Achenbach Graphic Arts Council for its
generous support of the publication of this book.

Special thanks are also given to Victoria Binder, Benjamin
Blackwell, Karin Breuer, Louise Chu, Julian Cox, Leslie Dutcher,
Erica Ellis, Debra Evans, Mark Garrett, James Ganz, Sue Grinols,
Stuart Hata, Danica Hodge, Don Larsen, Joseph McDonald, Lucy
Medrich, Tasha Monserrat, Laura Neufeld, and Tim Niedert for
helping to make this publication a reality.

Further thanks are given to Leah Finger, Brielyn Flones,
Jeremy Linden, Adrian Lucia, Ed Marquand, Ryan Polich, Brynn
Warriner, and Jeff Wincapaw for efficaciously overseeing produc-
tion of this book.

Title page: Max Klinger, *Penelope*. Detail of page 20.
Page 4: Kobayashi Kiyochika, *Fox and Crescent Moon*. Detail of
page 56.
Page 8: Utagawa Kuniyoshi, *Taihō, ebi* (*Phoenix and Lobster*). Detail
of page 75.
Page 18: Norbertine Bresslern-Roth, *Papageien* (*Parrots*). Detail of
page 58.